Ink Painting

UNDER THE AUSPICES OF

The Agency for Cultural Affairs
of the Japanese Government

EDITORIAL SUPERVISION
FOR THE SERIES

Tokyo National Museum
Kyoto National Museum
Nara National Museum

CONSULTING EDITORS
FOR THE ENGLISH VERSIONS

John M. Rosenfield
Department of Fine Arts, Harvard University

Louise Allison Cort
Fogg Art Museum, Harvard University

INK PAINTING

by Takaaki Matsushita

translated and adapted with an introduction by Martin Collcutt

New York · WEATHERHILL/SHIBUNDO · *Tokyo*

This book appeared in Japanese under the title Suibokuga (Ink Painting), as Volume 13 in the series Nihon no Bijutsu (Arts of Japan), published by Shibundō, Tokyo, 1967.

The English text is based directly on the Japanese original, though some small adaptations have been made in the interest of greater clarity for the Western reader. Modern Japanese names are given in Western style (surname last), while premodern names follow the Japanese style (surname first).

For a list of the volumes in the series, see the end of the book.

First edition, 1974

Published jointly by John Weatherhill, Inc., 149 Madison Avenue, New York, N.Y. 10016, with editorial offices at 7-6-13 Roppongi, Minato-ku, Tokyo; and Shibundō, 27 Haraikata-machi, Shinjuku-ku, Tokyo. Copyright © 1967, 1974 by Shibundō; all rights reserved. Printed in Japan.

ISBN 0-8348-2712-3 (hard) 0-8348-2713-1 (soft) LCC 73-88476

Contents

Translator's Preface 7

Introduction 9

1 The Art of Ink and Water 13

2 Suibokuga in Japan 27

3 The Shōkoku-ji Painters 48

4 Sesshū 70

5 The Daitoku-ji and Ami Painters 89

6 The Kamakura Tradition 110

7 The Kanō School 121

8 Later Painters: The Momoyama and Edo Periods 126

Glossary 138

Bibliography 140

Index 141

Translator's Preface

INK PAINTING is one of the most brilliant expressions of the artistic and intellectual sensibility of the peoples of China, Korea, and Japan. For centuries it has been accepted in East Asia that "a man's calligraphy reflects his self," and it is ultimately only a small step from the use of brush and ink for writing to their use for painting, from the expression of self through calligraphy to the expression of one's mental vision in an ink painting.

Mr. Matsushita in this study traces the development of Japanese ink painting from its origins in T'ang China to maturation in Muromachi Japan, where it became the major strand in Japanese painting. He explores the philosophical assumptions on which ink painting rested; examines the role of Zen monks and monasteries in its introduction to and growth in Japan, and shows how, while ink painting was becoming increasingly acclimatized in Japan, it continued to draw inspiration from China and Korea. With the encouragement of the author, every effort has been made to make the subject as fully accessible to the Western reader as possible. To this end an introduction, glossary, and bibliography of selected works in English have been included. In the translation details have been added that, while unnecessary for a Japanese reader, may be helpful to one less familiar with the cultural background. There has also been some rearrangement of the balance of material between chapters and the order of presentation within each chapter. These changes have the approval of the author, who has read and commented on the translation. The aim throughout has been to present the author's views accurately in clear, readable English.

I would sincerely like to thank Mr. Matsushita for his assistance and comments on the translation. My thanks also to Professor John Rosenfield for criticism and encouragement, and to my wife Akiko for help with the translation and the chore of typing the manuscript. Final responsibility for the translation rests, of course, with the translator.

M. C.

Introduction

DROPLETS OF WATER gather to a pool on the dark stone surface of an ink tray. The silence of the room is broken by the gentle, rhythmical scrape of ink stick against stone. Water and ink meet, mingle, and turn through cloudy gray to deepest black. Blank silk. The painter stills his breathing, dips the brush into the dark pool in the well of the ink tray, poises, and launches into the first stroke. Powerful strokes of the brush create a mountain ridge, torrents, plunging waterfalls, a twisted pine clinging tenaciously to a precipitous craggy face. Soft touches produce a wraith of clouds and the feathery foliage of bamboo bending with the wind on lower slopes. Farther down the silk one clean, sweeping line outlines a curving lake shore. Rapid strokes add a flight of evening birds, fishing boats moored before a lakeside cottage, a solitary figure on a lonely road. Emptiness at the center gives to the mountains an aura of grandeur, distance, and tranquillity. The painter adds his seal. A friend, perhaps, contributes an appropriate verse.

The work is complete, and yet its life has just begun. Mounted on silk brocade as a hanging scroll, it may grace the book-lined study of a Chinese scholar or the tokonoma (alcove) of a Japanese merchant's tearoom. On a folding screen *(byōbu)* it may keep winter drafts from the shoulders of an ailing ruler and bring to mind spring scenes he may not live to see again. On *fusuma,* or sliding panels, it may perhaps come to decorate the rooms of the abbot of a great metropolitan Zen monastery, complementing and blending with the natural landscape or garden sweeping away into the distance outside.

At first sight, the world of ink painting seems fragmentary, aloof, and forbidding. Rough mountains and jagged peaks tower over tiny figures. Lonely roads wind through deep and gloomy valleys. The figures who do appear are frequently wild-eyed, disheveled eccentrics, unfamiliar Buddhist deities, or scholarly Confucian sages who seem intent on preserving their privacy and keeping the world at bay. Although the flora—principally the plum, pine, bamboo, and orchid—is familiar enough, the fauna includes a motley assortment of beasts: tigers and dragons, oxen and asses, catfish and crayfish, geese and sparrows. One wonders what, if anything, these various elements can possibly have in common.

Increasing acquaintance with this strange realm, however, brings a sense of coherence and familiarity. The tiger is found to be man's companion; the squirming catfish, an expression of his wayward mind; the plum, a symbol of his purity and of the purity of nature. The uncouth, alien figures, the meditating monks and Bodhisattvas turn out to be bent on a quest common to all men: the understanding of self. The towering mountains and empty valleys, at first so menacing, become welcome havens of tranquillity. Fragments that had at first seemed unrelated unite to make up a world that has its own inner consistency, a world that expresses a coherent and compelling vision of life.

Ink Painting

1

The Art of Ink and Water

An ink painting is a creation of the inward eye of imagination, the spontaneous release of impressions and observations stored and charged in the mind. Deceptively simple, the art of ink monochrome demands of its exponents the mastery and blending of skills more subtle than those called for in faithfully reproducing and coloring the forms of objects presented to the physical eye. The ink painter must be able to vary the shade of the ink at will by the judicious mixing of ink and water; he must be able to impart nuances of expression to line and surface by his use of the brush, and he must be able to predict and control precisely the effect of the meeting of ink with paper or silk through the medium of the brush. The art of *suibokuga* demands also that the painter convey his insight with clarity as well as brevity.

Three Early Masters

Chinese painting was almost exclusively painting in color until the mid-T'ang dynasty (618–906), when three masters of ink monochrome gave to the new genre its basic form and techniques. Wu Tao-tzu, a master of the powerful stroke of the fully charged brush, used ink boldly, adding slight touches of color. Wu painted mostly supernatural and human figures, especially scenes of the Buddhist hells, but one anecdote records that he painted in ink a massive panorama of the scenery along the Chialing River in present-day Ssechwan Province in a single day. True or not, this story illustrates one cardinal element of ink painting: its spontaneity.

Wang Wei (? 701–61) is renowned as one of China's

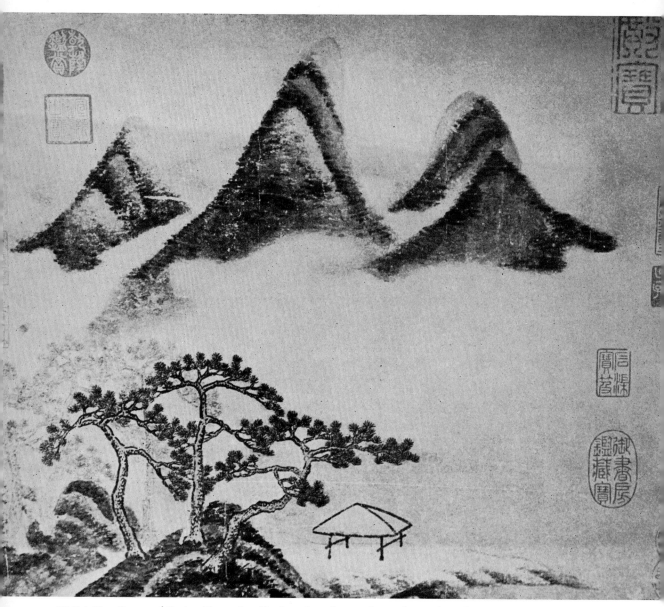

1. *Mi Fei:* Pine Trees and Spring Mountains. *Northern Sung dynasty, late 11th or early 12th century. National Palace Museum, Taipei.*

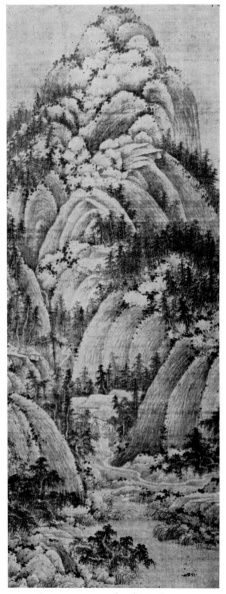

2. *Chü Jan:* Road through Autumn Mountains. *Ink on silk. Northern Sung dynasty, late 10th century. National Palace Museum, Taipei.*

finest poets and, because of his fluent combination of literary and artistic genius, as the founder of the genre known as literati painting. In difficulties during the An-Shih Rebellion (755–63), Wang subsequently withdrew from political and social activity to a life of rural seclusion devoted to poetry, music, and landscape painting in ink. His paintings were mostly of peaceful rural scenes painted with gentle touches of the brush, and their perfect mirroring of his acute poetic sensibility stirred Su Shih (also known as Su Tung-p'o; 1036–1101), a literary giant of the Sung dynasty (960–1279), to remark, "There is painting in his poetry, poetry in his painting."

One of the fundamental techniques of ink painting is that of *haboku* (in Chinese, *p'o-mo*), or "broken ink" style, in which the shade of the ink is varied by the use of alternating thick and thin lines and ink washes to convey nuances of texture, mood, and movement in the painting. In China there were said to be five shades of ink, and Wang's subtlety in using them to maximum effect was such that he is generally regarded as the originator of the *haboku* technique. Wang Mo (d. c. 804) developed another basic ink painting technique, that of *hatsuboku* (in Chinese, *p'o-mo*) or "splashed ink" style, in which the painter, responding to the demands of his imagination, splashes and spatters ink, allowing the painting almost to shape itself. Wang Mo is even said to have daubed ink onto the silk with his hands and feet, and smeared it on with his hair.

None of their works survive, but we know that with the meeting of Wu Tao-tzu's spirited brushwork, Wang Wei's skillful variation of shade, and Wang Mo's explosive *hatsuboku* technique, ink painting emerged as an independent genre of great technical and artistic subtlety. It gained adherents, developed as a countertradition to color painting, and played a pivotal role in the history of Chinese painting. The techniques initiated by these three men were further elaborated and diversified, rules and techniques of expression established, and the genre given final form by such painters as Ching Hao and Kuan T'ung of the late T'ang and Five Dynasties (907–60) periods; Li Ch'eng, Fan K'uan (Plate 4), Tung Yüan, Mi Fei (Plate 1), Kuo Hsi (Plate 3), Chü Jan (Plate 2), and Yen Wen-kuei (Plate 12) of the Northern Sung

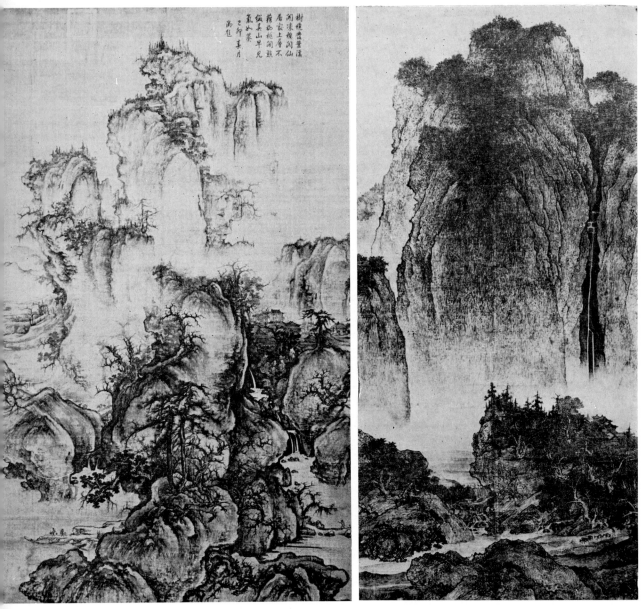

3. (left) Kuo Hsi: Landscape: Early Spring. *Ink on silk. Northern Sung dynasty, 11th century. National Palace Museum, Taipei.*
4. (right) Fan K'uan: Traveling among Mountains and Streams. *Ink on silk. Northern Sung dynasty, early 11th century. National Palace Museum, Taipei.*

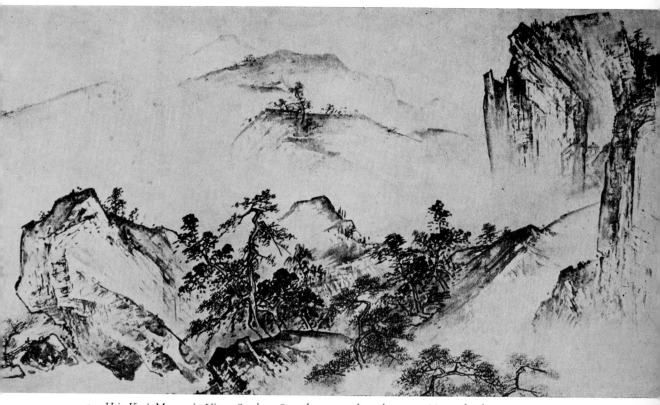

5. *Hsia Kuei:* Mountain Vista. *Southern Sung dynasty, early 13th century. National Palace Museum, Taipei.*

dynasty (960–1127); Li T'ang, Ma Yüan (Plate 8), Hsia Kuei (Plates 5, 9), Yen T'zu-ping (Plate 23), and Liang K'ai (Plate 25) of the Southern Sung (1127–1279); Wang Meng (Plate 10), Wu Chen, Ni Tsan, and Kao K'o-kung (Plate 11) of the Yüan dynasty (1279–1368). These and numerous other masters of the Ming (1368–1644) and Ch'ing (1644–1912) dynasties all used ink as their principal medium of expression, and despite individual differences in style, all shared a common impulse: to express in a single exhalation images that filled their minds without losing the sense of the immanent divinity of nature.

Zen

Behind the observable forms, ink paintings were therefore pervaded by a philosophical, literary, and religious spirit. Because this in turn demanded a high level of cultural attainment and learning in addition to technical skill, many artists were members of the gentry class; they were scholars, literati, and monks—men with a range of talents and interests not normally found in ordinary journeyman painters. Zen (in Chinese, Ch'an) monks were especially prominent among ink painters, and Zen motifs constantly recur in ink paintings.

Zen derives from the Sanskrit *dhyāna,* meaning meditation or contemplation. Zen is also the name given to the Buddhist sect which teaches that the true nature of one's mind, its identity with the Buddha nature immanent in all things, can only be realized intuitively in an enlightenment achieved through con-

6. *Yü Chien:* The Lu Shan Mountains. *Ink on silk; ht 35, w 62.5 cm. Important Cultural Property. Three Chinese painters called themselves Yü Chien. This work is thought to have been painted by Yü Chien Te-ying, the disciple of the early Sung Zen master Ch'ih-chüeh Tao-Ch'ung. Characteristic of Zen painting in its rough and simple brushwork, the painting evokes the smoky, misty mountains of Lu Shan in southern China. The famous Lu Shan falls were originally included at the left of the painting, but this section was later detached and mounted separately. Sesshū and other Japanese painters were attracted and strongly influenced by the wraithlike, dissolving forms of Yü Chien's paintings and by his "splashed ink" technique. Southern Sung dynasty, 12th century. Yoshikawa Collection, Tokyo.*

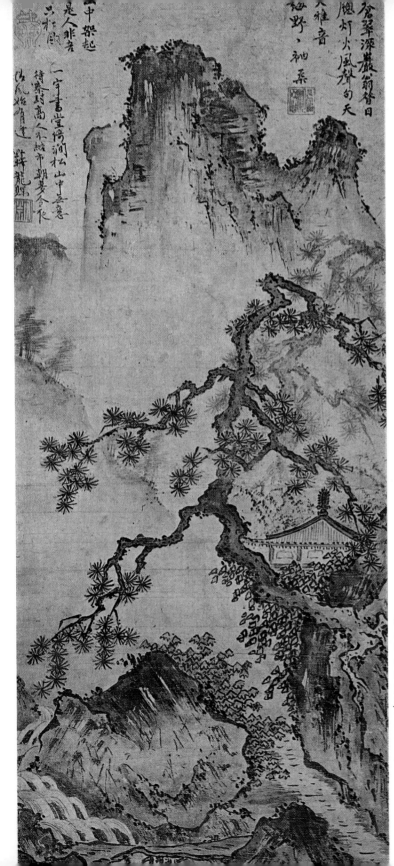

7. The Pine Wind Pavilion. *Artist unknown; inscriptions by five monks. Ink and colors on paper; ht 100.2, w 31.7 cm. Important Cultural Property. This is one of a large number of Chinese and Japanese ink paintings on the theme of the scholar's retreat. The painting is probably a product of the Minchō school of Tō-fuku-ji painters, an attribution reinforced by the vigorous descriptive style that derives from the work of painters in the Ningpo region of China, who exerted considerable influence on Tōfuku-ji painters. This painting is distinguished by a vitality lost in subsequent, more formalized landscapes on the same theme. 1433. Seikadō Foundation, Tokyo.*

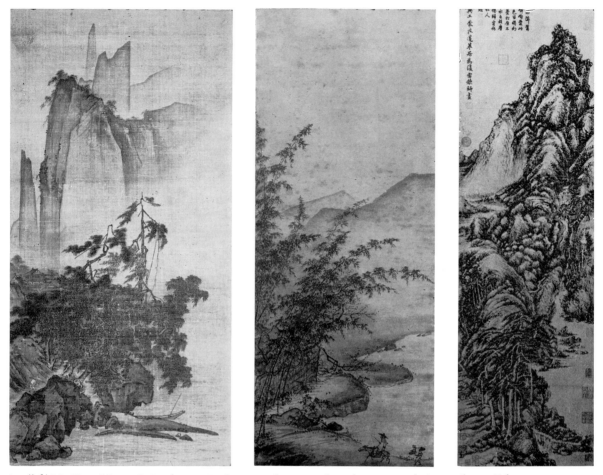

8. *(left) Ma Yüan:* Mountain Landscape. *Southern Sung dynasty, early 13th century. Seikadō Foundation, Tokyo.*
9. *(center) Hsia Kuei:* Bamboo Grove and Mountain Landscape. *Early 13th century. Asano Collection, Tokyo.*
10. *(right) Wang Meng:* Isolated Temple in an Autumn Landscape. *Yüan dynasty, 14th century. National Palace Museum, Taipei.*

centrated meditation *(zazen)*. The practices of Zen are said to have been brought to China toward the end of the fifth century by the Indian monk Bodhidharma. Bodhidharma's immediate disciples were few, but during the T'ang dynasty Zen gained large numbers of adherents; it became an independent sect that was soon to be the most influential branch of Buddhism surviving in China. Zen schools differed slightly in their emphasis on the basic teachings. The Southern School, for instance, deriving from the sixth patriarch, Hui-neng, stressed "sudden enlightenment" as opposed to the "gradual enlightenment" espoused by Hui-neng's rival Shen-hsiu, founder of the short-lived

Northern School. Some masters of the Southern School used *kōan* in addition to *zazen* in the training of disciples. A *kōan* is a rationally insoluble problem upon which a student of Zen works constantly until he realizes it in a moment of intuitive insight of the same order as that of his master and of Sākyamuni himself.

The teachings and meditation methods of the Chinese Zen schools were known in Japan from the Nara period, and seated meditation *(zazen)* formed an important part of the practices of the Tendai sect. Zen, however, did not take independent root in Japan until Myōan Eisai (1141–1215) brought back from Sung

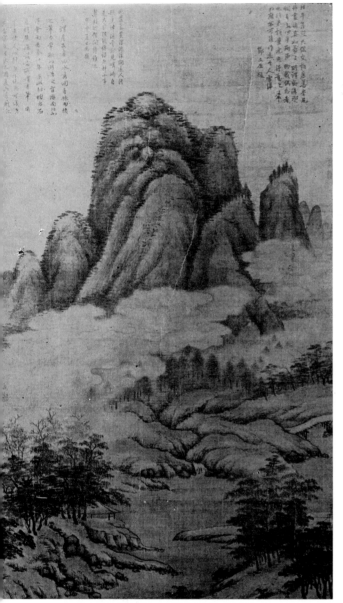

11. *Kao K'o-kung:* Mountains and Drifting Clouds. *Colors on silk. Yüan dynasty. National Palace Museum, Taipei.*

China the teachings of Rinzai Zen, which combined *kōan* study with *zazen*. Dōgen (1200–53) introduced Sōtō Zen practice, which placed greater emphasis on quietly receptive meditation *(zazen)*. Zen's stress on the need for every man to relive the Buddha's enlightenment; its rejection of rational, commonplace understanding of self and the world about one as obstructions to this higher perception; its active introspection and sensitivity to nature; its freedom of mind and discipline of will all appealed strongly to Chinese poets and artists, especially those responsive to its resonances with the Chinese Taoist tradition. These same qualities were later to appeal even more strongly to Japanese artists and warriors.

In explaining the rise of ink painting after the mid-T'ang period and its close association with Zen, some Chinese historians have pointed to the impact of sweeping social and political changes on standards of taste and cultural values. As central authority wavered in the face of local interests asserted by powerful provincial clans, the T'ang empire began to disintegrate politically and economically. In keeping with a new, more rigorous age, it is suggested, there was a shift in cultural and aesthetic interest from the flamboyant to the plain. Zen was the most vigorous Buddhist sect and many of the gentry, under the influence of its unworldly ideal, developed a preference for the quintessential simplicity of ink and water over the glitter of gold and azure.

The paintings shown in Plates 14, 15, and 16, for example, illustrate these qualities in the form of studies of figures common in Zen painting. Plate 15 shows Pu-tai (in Japanese, Hotei), a possibly legendary, jovial Zen sage who wandered about the country in search of alms. (His name means "hemp sack" or perhaps "pot-belly.") Pu-tai, in popular belief, was revered as a manifestation of the Bodhisattva Maitreya. His bountiful form held great appeal for Chinese and Japanese ink painters (see, for example, Plates 124, 133). He appears in many paintings—belly bare, grasping a staff, and carrying, dragging, or sitting on the enormous sack into which he is said to have crammed the proceeds of his mendicancy.

Feng Kan (Plate 16), poet, mystic, companion of Han-shan and Shih-te and, like Pu-tai, an incarnation of Maitreya, is said to have startled his disciples by

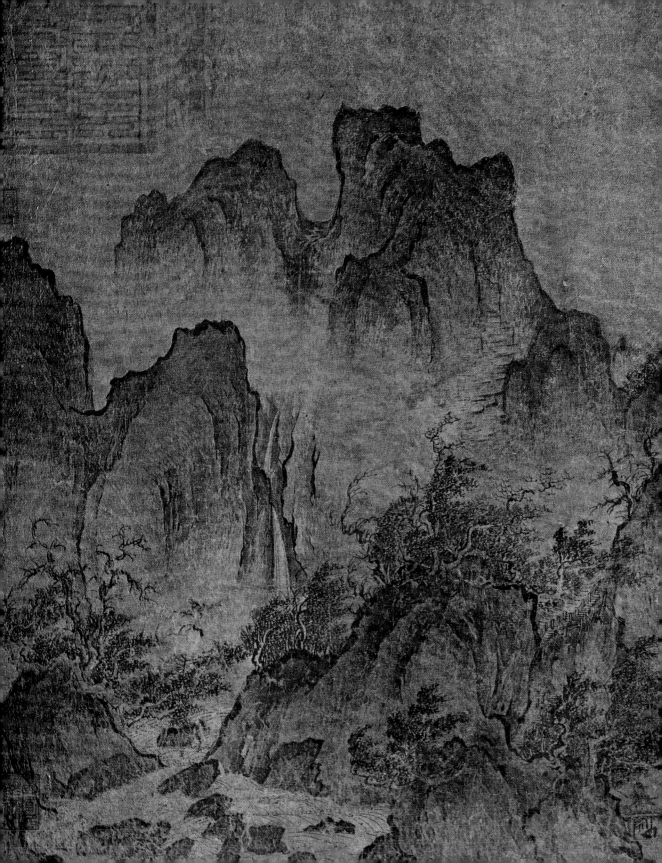

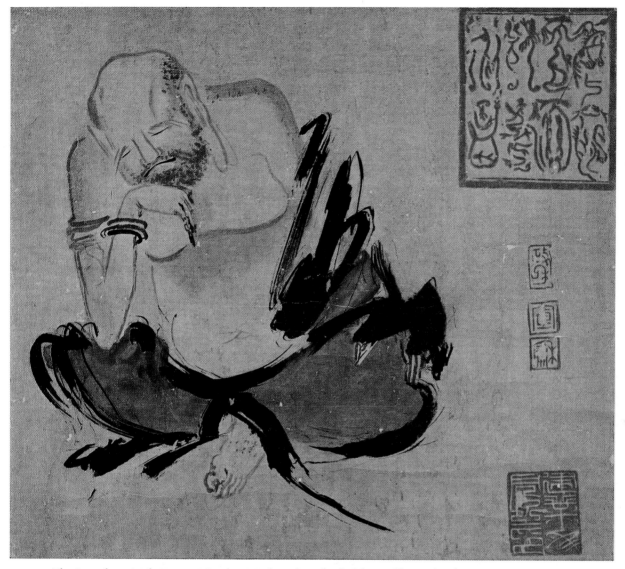

13. **The Second Patriarch Harmonizing His Mind.** *In the style of Shih K'o (d. c. 975). Ink on paper, ht 35.5, w 64.3 cm. Important Cultural Property. Although this painting is almost certainly not by Shih K'o, it is generally accepted as conveying what is known of his abbreviated, free-flowing style—a blend of conventional fine brushwork for face, hands, and feet with deliberately rough brushwork and uneven ink distribution for the garments achieved by the use of something like a shredded bamboo brush. There is some doubt as to whether this painting does, in fact, show the second patriarch. It is also unclear whether the subject is meditating, musing, or sleeping off the effects of rice wine. The work remains, however, an extremely powerful ink figure study and a fine example of the category of Zen-inspired painting known as i-p'in, or "untrammeled" painting. Five Dynasties–Northern Sung period. Tokyo National Museum.*

◁ 12. **Yen Wen-kuei:** Landscape. *Detail. Ink on silk. Yen Wen-kuei specialized in landscapes of the four seasons. As is clear from this example, his paintings are rich in atmosphere, detailed in composition, and finely textured. The influence of this style of notched and rugged rock formations, slender waterfalls, mist-shrouded valleys, and wiry trees can be detected again and again in subsequent Chinese and Japanese ink paintings. Northern Sung dynasty, late 10th to 11th century. Osaka Municipal Art Museum.*

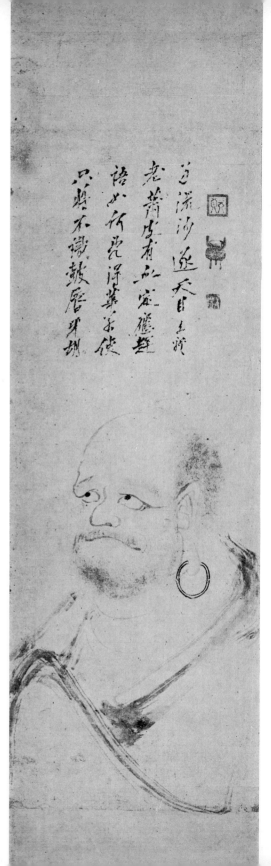

14. Bodhidharma. *Artist unknown. Inscription by Mieh-weng Wen-li (?1167–?1250). Ink on paper; ht 110.3, w 32.7 cm. Southern Sung dynasty. Myōshin-ji, Kyoto.*
15. *(near right)* Li Ch'üeh: Pu-tai. *Inscription by Yen-ch'i Kuang-wen (1189–1263). Ink on paper; ht 105.4, w 32.4 cm. Southern Sung dynasty, 13th century. Myōshin-ji, Kyoto.*
16. *(far right)* Li Ch'üeh: Zen Master Feng Kan. *Inscription by Yen-ch'i Kuang-wen. Ink on paper; ht 105, w 32.4 cm. Southern Sung dynasty. Myōshin-ji, Kyoto.*

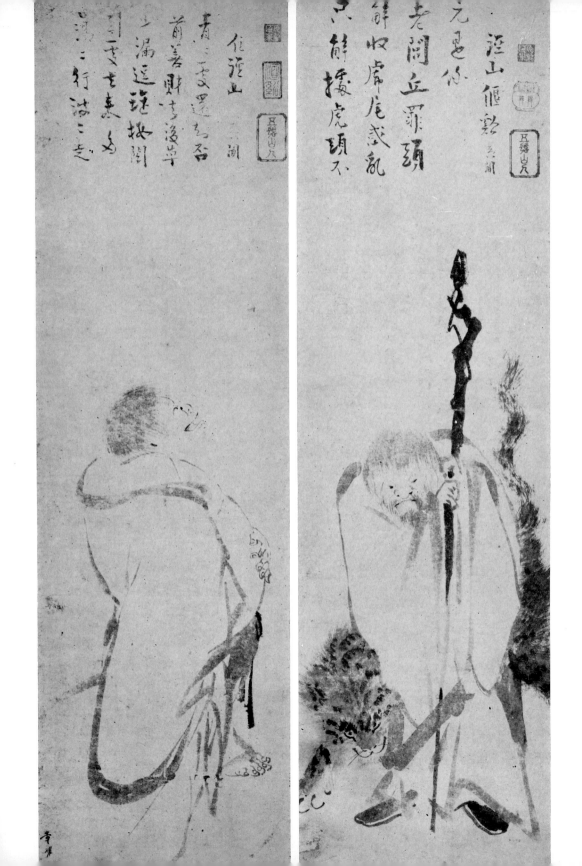

riding about on a tiger. The precise Zen significance of the tiger is open to a variety of interpretations, but Feng Kan and his tiger are a common motif in Zen painting (see Plate 51). This is a companion to the figure study of Pu-tai (Plate 15), and the two paintings usually flank the Bodhidharma painting (Plate 14), which was almost certainly not by Li Ch'üeh. The Pu-tai and Feng Kan studies are clearly very much alike in line quality, in the painting of hair, in the use of dots of ink for eyes, nostrils, and ears, and in the focus of energy in a single hand.

Without pressing the analogy too far, we can suggest that there is something in common between the search for Zen enlightenment, which involves a return to a unity of primal emptiness, and the attempt to express reality and the world of things in ink, the primal color. Certainly many Zen monks produced ink paintings as one expression of their enlightenment and these works, whatever their technical attainments, are imbued with a moving simplicity and freedom of spirit.

2

Suibokuga in Japan

Until well into the medieval period, Japanese paint-ing was dominated by two traditions: Buddhist sub-jects done in a largely international style, and narrative picture scrolls done in the native Japanese, or *yamato-e,* style. Both traditions stressed color and decorative effects. Most painters were artisans known as *ebusshi* (masters of Buddhist painting) or *eshi* (master paint-ers) who were governed more by precedent than by the desire for personal expression. Ink painting, which had a long history in China, did not begin in Japan until the Kamakura period (1185–1336), and its first secular patrons were not members of the imperial family or court nobles of Kyoto, who had been the focus of Heian culture, but new holders of power, the warrior overlords who succeeded Minamoto Yori-tomo, the founder of the Kamakura military regime

(bakufu). The few early Japanese paintings in ink alone, such as the elegant Bodhisattva drawn in ink on linen (a product of the Nara period now in the Shōsōin collection), or the delightful Heian-period scrolls of birds and animals caricaturing human foibles, are rather isolated exceptions.

The Role of Zen

Chinese ink painting was brought to Japan in the latter half of the thirteenth century by Chinese and Japanese Zen monks, men whose interests were un-usually broad. By that time, Zen monks in China were no longer simply practitioners of meditation or exponents of only Zen ideas and attitudes. Practical and down to earth, learned, cultured and witty, many

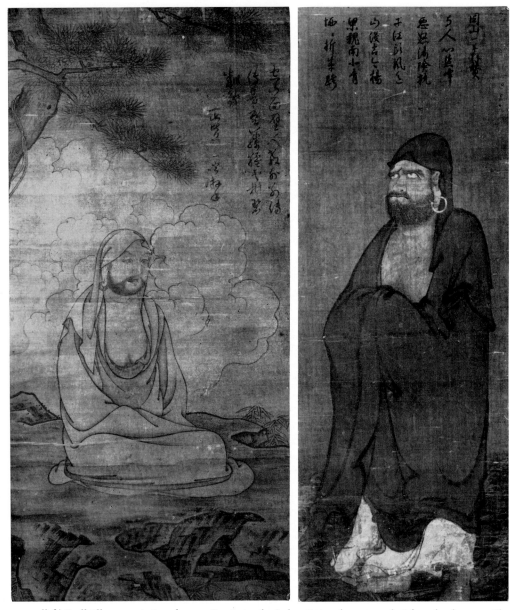

17. *(left)* Bodhidharma. *Artist unknown. Inscription by I-shan I-ning (1247–1317). Ink and colors on silk; ht 99, w 45 cm. Important Cultural Property. Early 14th century. Tokyo National Museum.*
18. *(right)* Bodhidharma Crossing the Yangtze on a Reed. *Artist unknown. Inscription by Kozan Ikkyō. Ink and colors on paper. Early 14th century. Gyokuzō-in, Kyoto.*

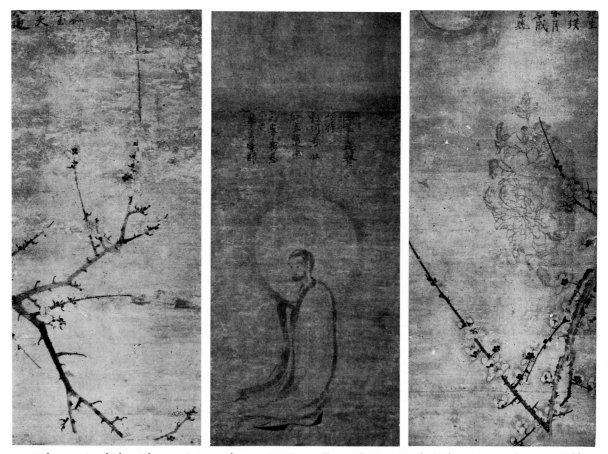

19. Sākyamuni and Plum Blossoms. *Artist unknown. Hanging scroll triptych. Inscription by Hakuun Egyō. 13th century. Rikkyo-ku-an, Tōfuku-ji, Kyoto.*

were on intimate terms with members of the Chinese social, political, and intellectual elite whose cultural values they shared. As familiar with Taoist and Confucian ideas as they were with Buddhist doctrines or Zen metaphysics, these monks were often accomplished calligraphers, poets, and painters who drew on the whole range of Chinese culture and the Indian Buddhist tradition, blending and transmuting both into a unique Zen vision of life.

The Zen monks who brought ink paintings to Japan also brought knowledge of the painting techniques employed, of the spiritual and intellectual attitudes that informed them, and of the theoretical basis for their enjoyment. I-shan I-ning (1247–1317), for example, was a scholarly Chinese monk who came to

Japan in 1299 as an emissary from Mongol China. Declining to return, he was, after a period of suspicion and surveillance, installed by the Japanese military rulers as abbot of the Kamakura Zen monasteries of Kenchō-ji and Engaku-ji, and later of Nanzen-ji in Kyoto. Besides introducing Sung-style Zen, I-shan was one of the first to discuss the ideas of Chu-hsi (1130–1200) and the Neo-Confucian thinkers in Japan. He also encouraged the literary movement based on the study of Chinese poetry that was to thrive as the so-called Literature of the Five Mountains (*gozan bungaku*). And I-shan and his colleagues used the study of Chinese thought and poetry as well as Zen metaphysics to inculcate a comprehensive understanding of ink painting.

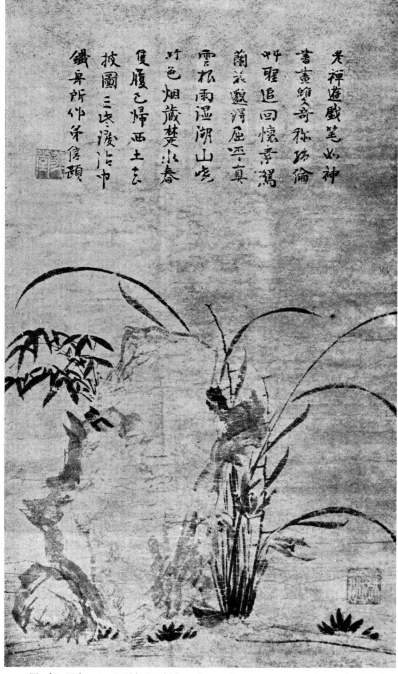

20. *Tesshū Tokusai:* Wild Orchid and Bamboo. *Inscription by Gidō Shūshin (1325–88). Ink on paper. c. 1350. Gotō Art Museum, Tokyo.*

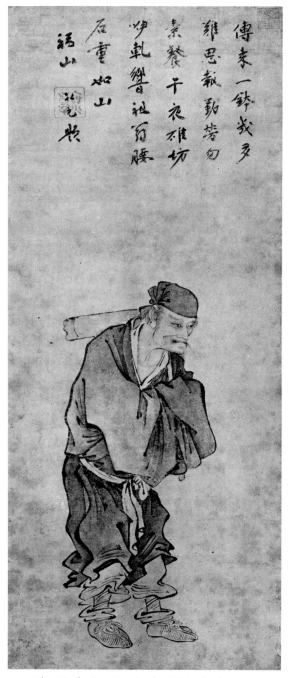

21. *The Sixth Zen Patriarch (Hui Neng). Artist unknown. Inscription by Wu-hsüeh Tsu-yüan (1226–86). Ink and colors on paper; ht 83.3, w 34.8 cm. Important Cultural Property. Late 13th century. Masaki Collection, Osaka.*

The original "five mountains" were the five great monasteries capping the pyramid of official Zen monasteries in Sung China. The "five mountains" system began to be copied in Japan in the late Kamakura period and was completed under the patronage and control of the Ashikaga shoguns (military rulers). The Japanese system was not an exact copy of the Chinese model: As the system developed in Japan, five Kamakura and five Kyoto monasteries were ranked as *gozan,* with the Kyoto monastery of Nanzen-ji set in a transcendent position above them. The Japanese *gozan* were dominated by the Rinzai lines of Zen, especially those of Shōichi Kokushi, founder of Tōfuku-ji, and Musō Soseki, founder of Tenryū-ji and close confidant of the Ashikaga shoguns. Modeling themselves closely on Sung and Yüan Chinese monastic practice, the Japanese *gozan* quickly became centers of Chinese learning and culture. *Gozan* monasteries having a particularly potent influence on the introduction and growth of ink painting included the Kamakura monasteries of Kenchō-ji and Engaku-ji, and the Kyoto monasteries of Tōfuku-ji, Shōkoku-ji, and Daitoku-ji, a Rinzai monastery temporarily included in the *gozan.*

Once introduced, ink painting rapidly took root and by the late fourteenth century had eclipsed the more traditional modes of painting to become the most vital form of Japanese art. Because of the spiritual influence of Zen monks on the warrior class and the close personal ties between them, interest in *suibokuga* gradually spread from the monastic environment that had fostered it to the mansions and villas of samurai. Some of the Ashikaga shoguns were accomplished ink painters in their own right, but more important, they set an example for the whole warrior class by collecting old Chinese paintings and commissioning new ones, by holding tea ceremonies and poetry gatherings at which newly acquired works were discussed and inscriptions added, and by surrounding themselves with artists, poets, and connoisseurs. Ink painting thus became one of the brilliant threads in the distinctive fabric of the culture of medieval Japan.

Restoration of direct imperial rule by Emperor Godaigo (1288–1339) in 1333 had brought to an end the Kamakura *bakufu.* Godaigo's success, however, was short-lived. In 1336 he was driven from Kyoto

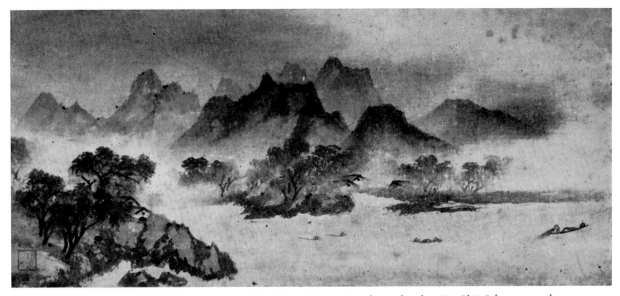

22. Fishing Village at Dusk. *From* Eight Views of the Hsiao-Hsiang. *Detail. Attributed to Mu Ch'i. Ink on paper; ht 32.9, w 112 cm. National Treasure. Southern Sung dynasty, 13th century. Nezu Art Museum, Tokyo.*

23. Water Buffaloes in an Autumn Landscape. *Attributed to Yen T'zu-ping. Colors on silk; ht 98.2, w 50 cm. National Treasure.* ▷
Yen T'zu-ping's father Yen Chung also painted water buffalo, as did Li T'ang, with whom Yen is said to have studied landscape painting. Certainly, traces of Li T'ang's style are evident in this important example of the work of the Sung Academy prior to Ma Yüan and Hsia Kuei. Early Southern Sung dynasty, 12th century. Sumitomo Collection, Kyoto.

by an erstwhile supporter, the warrior leader Ashikaga Takauji (1305–58), who set a puppet on the imperial throne, declared himself shogun, and established his regime *(bakufu)* in the Muromachi district of Kyoto. Takauji was the first of fifteen Ashikaga shoguns and the period of their rule, from 1336 to 1568, is generally referred to as the Ashikaga or Muromachi period. The Ashikaga shoguns were devoted patrons, and in many cases skilled practitioners, of the arts, and the long period of their rule saw the development and refinement of many of those arts that are today regarded as most characteristically Japanese in spirit and sensibility. Their choice of the ancient court capital of Kyoto as their center of rule produced a unique blending of warrior and aristocratic cultural traditions. To increase their tax income, the Ashikaga encouraged licensed trade with China by merchant and monastic venturers whose vessels brought back a wealth of Chinese art objects that were to provide inspiration for Japanese artists and craftsmen. Ashikaga political control, never very broad based and always dependent upon a potentially unstable alliance between the shoguns and a number of provincial warrior leaders, was strained by increasing social unrest in the later fifteenth century and critically weakened by the Onin wars (1467–77).

Japanese Pioneers

Two kinds of painters were to be found in the large metropolitan Zen monasteries such as Tōfuku-ji in Kyoto. One was virtually a professional Buddhist

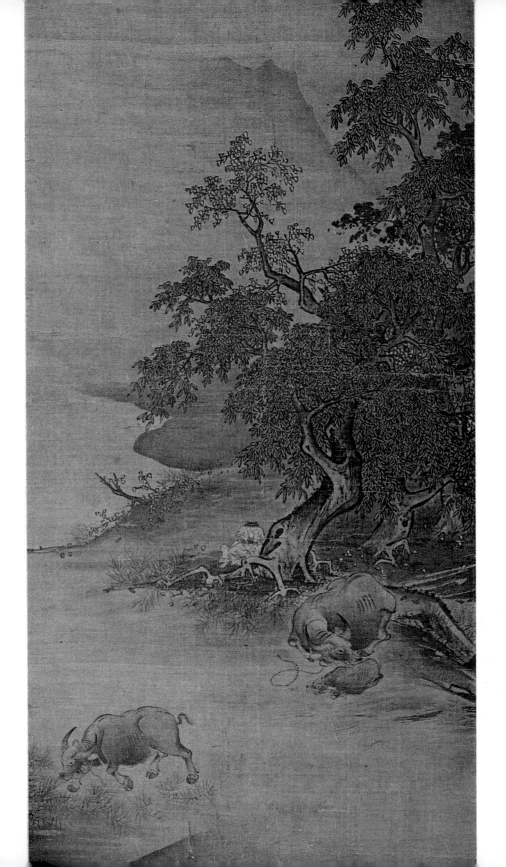

24. *Yü Chien:* Mountain Landscape. *From* Eight Views of the Hsiao-Hsiang. *Ink on paper; ht 33, w 84 cm. Southern Sung dynasty, 12th–13th century. Yoshikawa Collection, Tokyo.*

artist, like the traditional *ebusshi,* who painted the ornate votive pictures used in public ceremonies; the other was a monk for whom painting with ink and water was part of his personal or religious discipline. The earliest Japanese ink paintings occasionally retain color or line qualities from traditional Buddhist paintings, as in representations of the Indian monk Bodhidharma (Plates 17, 18, 26), or of his illustrious patriarch successors (Plate 21).

Bodhidharma, who is believed to have brought Zen teaching to China, has inspired many fine ink paintings. In early portraits he appears as a frail, elderly Chinese monk. As the icon captured the imagination of painters, however, he began to be portrayed as a robust man in the prime of life, heavily bearded and adorned with earrings as a mark of his Indian origin.

The figure shown in Plate 17 seems human and approachable. In later paintings the eyes become more prominent, the features more truculent, and the figure generally more remote. This painting is an interesting early example of a work by a painter of Buddhist subjects who, probably under the influence of I-shan, was experimenting with ink. In the full-face study of Bodhidharma shown in Plate 26, the flowing lines of the robe give a sense of life and energy to the seated meditating figure. Although color is used for the hands and face, lips, teeth, and fingernails as well as the robe, the stylistic and compositional debt to ink-painting technique is clear.

As the accepted architect of the concept of "sudden enlightenment," Hui Neng (Plate 21) occupies a place in the Zen tradition second only to Bodhi-

dharma. The hoe is at once a mark of his supposedly humble background, a symbol of the Zen emphasis on manual labor, and a reminder that enlightenment can be found in the most commonplace of everyday activities. Wu-hsüeh, a Chinese monk invited to Japan in 1279 by Hōjō Tokimune, inscribed this painting between 1282 and 1286 when he was abbot of Engaku-ji. Most of the painting, by a specialist painter of Buddhist subjects who made use of Chinese models, thus belongs to the earliest phase of Japanese ink painting. The legs, however, seem to have been added or repainted later.

Other themes, such as plum blossoms (Plate 19) or orchids (Plate 20), are free from the influence of traditional Buddhist art. For example, eight famous views of the Hsiao and Hsiang rivers (Plate 31) provided popular subjects for Chinese and Japanese ink painters (see also Plates 22, 24). The painting by Mu Ch'i shown in Plate 22 is one of a famous sequence he did of views of the two rivers. Here he used a rough brush and extremely fine nuances to express the mist-laden atmosphere and looming mountains of the Hsiao-Hsiang region. Shitan's carefully detailed painting, one of a sequence to which I-shan is known to have added inscriptions, is among the earliest examples of Hsiao-Hsiang landscapes painted in Japan. Although nothing is known about Shitan, he was probably an *ebusshi,* or painter of Buddhist subjects, who was using as a model a painting on the same theme by one of the painters of the Ssuming region of China.

The orchid was a popular subject with Chinese and

25. *Liang K'ai:* Li Po Reciting. *Ink on paper. Important Cultural Property. This work was painted after Liang K'ai had abandoned the the Southern Sung Academy for the life of a Zen recluse. In no more than a dozen terse strokes, the painter presents the poet absorbed in a moment of creation. It was hardly surprising that his abbreviated, powerful style should have made a deep impression on many Japanese painters, including Josetsu, Sesshū, Kaihō Yūshō, and Miyamoto Musashi. Southern Sung dynasty, first half of the 13th century. Tokyo National Museum.*

26. *(opposite)* Bodhidharma. *Artist unknown. Inscription by Lan-ch'i Tao-lung. Ink and colors on silk; ht 123, w 61.2 cm. National Treasure. Bodhidharma (known as Daruma in Japan), who is believed to have brought Zen to China from India, was frequently a subject for Zen painters. Portrayals of him, however, show an interesting development: He appears first as as a frail, elderly Chinese monk; then as a man in the prime of life, bearded, swarthy, and wearing earrings as a sign of his Indian origin, but very human and approachable; and later as a remote figure with prominent eyes and a fierce expression. In this study, the enveloping red robe seems to fill the painting, the fluent brushstrokes which outline the robe and hood charging the work with energy and bringing the eye naturally to bear on the rapt features of the meditating patriarch. This particular full-face, seated posture is the forerunner of the later popular "meditation facing a wall" portrayals of Daruma. The painting itself, along with that shown in Plate 17, is one of the masterpieces of early Zen painting. Late 13th century. Kōgaku-ji, Yamanashi Prefecture.*

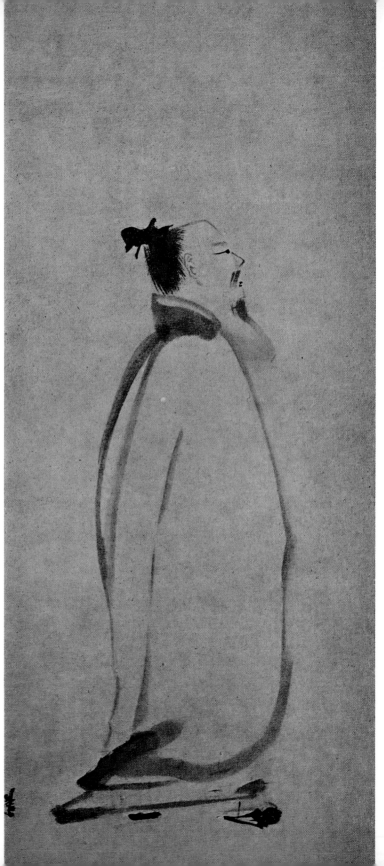

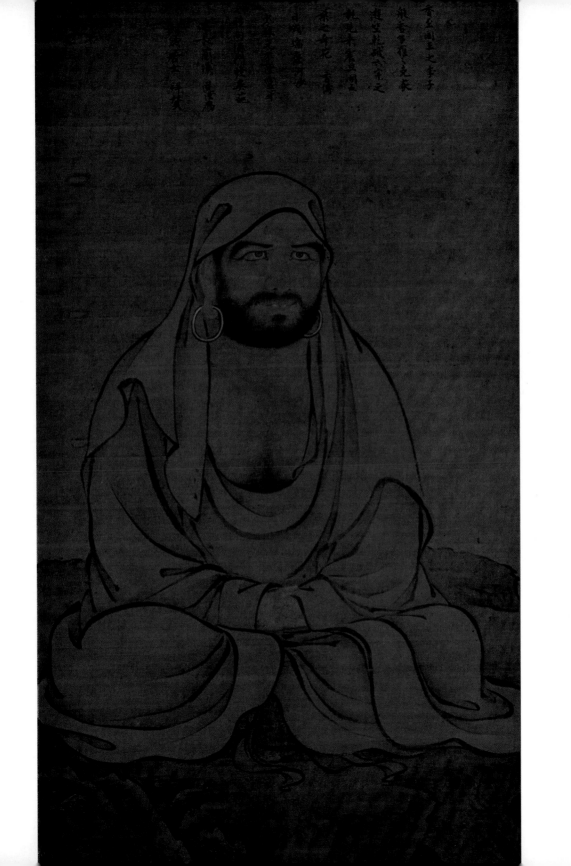

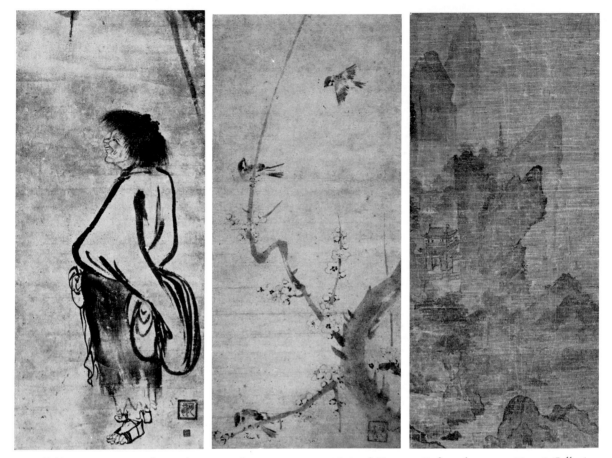

27. *(left) Kaō Sōnen:* Han-shan. *Ink on paper; ht 98.5, w 33.3 cm. National Treasure. Early 14th century. Hattori Collection, Tokyo.*
28. *(center) Kaō Sōnen:* Plum and Sparrows. *Early 14th century. Umezawa Collection, Tokyo.*
29. *(right) Kaō Sōnen:* Landscape. *Early 14th century. Hinohara Collection, Tokyo.*

Japanese ink painters because of its pliant delicacy, elegant beauty, and exquisite fragrance, and also for the challenge it presented in the exercise of long, flowing single brushstrokes. Tesshū, who did the painting shown in Plate 20, probably developed a love for the flower and skill in painting it while studying in China with the monk Hsüeh-ch'uang, who specialized in orchids. Paintings of flowers and birds composed one of the established categories of Chinese painting. The taste for such paintings developed in the T'ang dynasty, and they became extremely popular in the Sung dynasty. When introduced into Japan, they found

immediate favor. The category was fairly broad; flowers included trees and grasses, and insects and animals were sometimes included as well as birds. All these subjects became and remained favored motifs of Zen-inspired *suibokuga*.

With their clear-cut brushwork and simple lines depicting a single subject, with perhaps a poem added by the painter himself or some other monk, these paintings of the late thirteenth and fourteenth centuries may not at first sight seem outstanding compositions; in their directness, simplicity, and clarity of vision, however, they capture the essence of their sub-

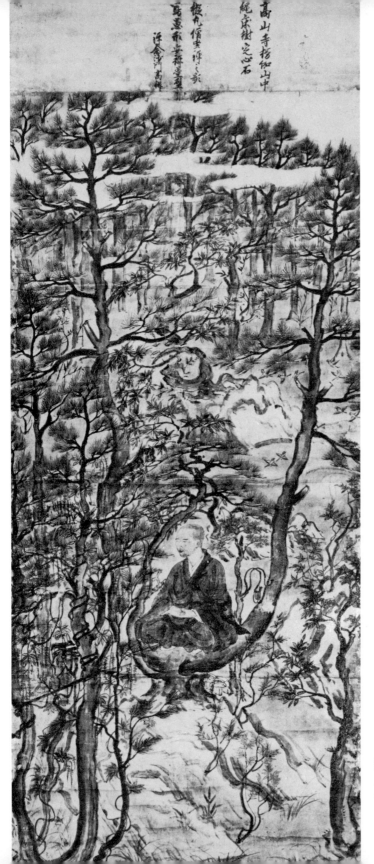

30. *Enichibō Jōnin:* Myō-e Shōnin Meditat-
ing. *Detail. Ink and colors on paper; ht 135, w
58.8 cm. National Treasure. Early 13th century.
Kōzan-ji, Kyoto.*

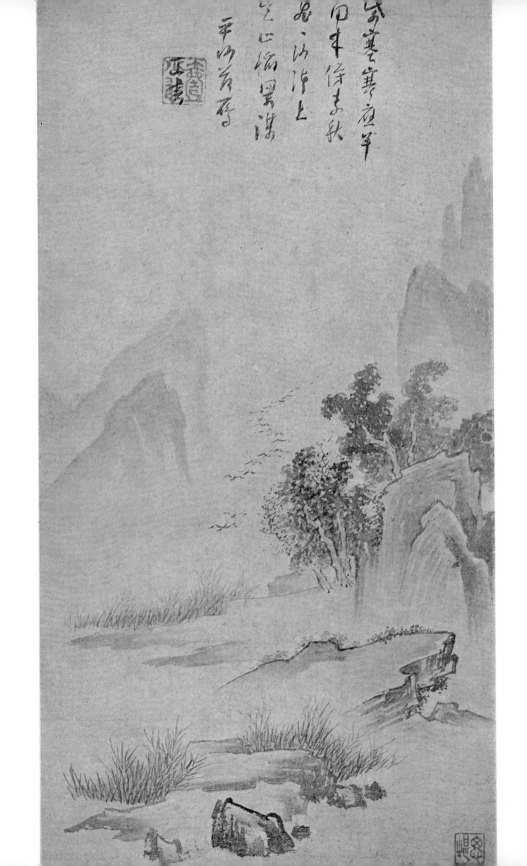

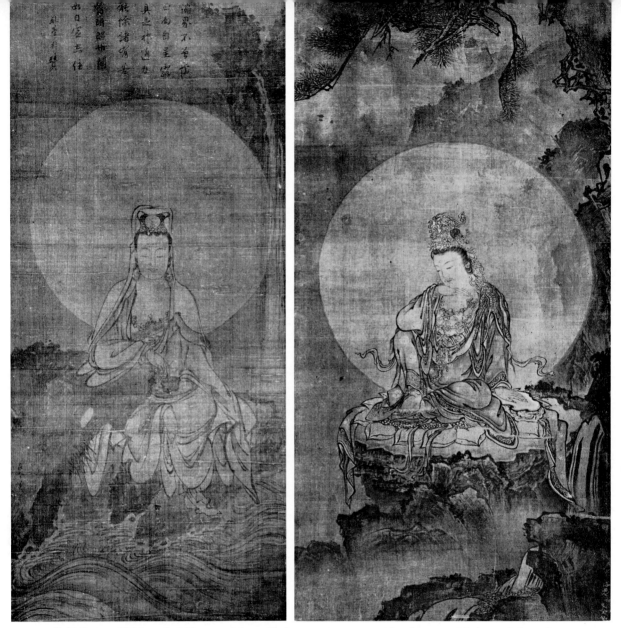

32. (left) Ryōsen: White-robed Kannon. *Ink on silk; ht 88.7, w 41 cm. c. mid-14th century. Myōkō-ji, Aichi Prefecture.*
33. (right) Ryōsen: Kannon. *Ink and gold on silk; ht 109.6, w 44.1 cm. c. mid-14th century. Yamamoto Collection, Tokyo.*

◁ 31. Wild Geese Approaching a Sandbar. *Signed Shitan. Inscription by I-shan I-ning (1247–1317). Ink on paper; ht 57.5, w 30.2 cm. Important Cultural Property. One of the earliest Japanese versions of the famous theme of the eight views of the Hsiao-Hsiang rivers region of China, the detailed, elegant execution of this painting shows the influence of Sung and Yüan styles on Japanese painters. Nothing is known of the painter, but I-shan, who added the inscription, was a Chinese monk who came to Japan in 1299 as an emissary from Mongol China and taught Chinese thought and poetry as well as Zen metaphysics. He was instrumental as well in introducing to Japan the literary studies that were to develop as gozan bungaku. Early 14th century. Satomi Collection, Kyoto.*

ject and clearly reflect the taste and ideals of the Zen monks who painted them. This freshness and clarity injected new vitality into Japanese painting and opened new horizons to Japanese painters.

The first and one of the most gifted of Japanese ink painters was the Tōfuku-ji monk Kaō Sōnen (d. 1345). Kaō journeyed to China to further his knowledge of Zen and to study ink painting, and during a twelve-year stay earned respect in Chinese Zen circles both for his Zen and his painting. On account, no doubt, of the depth of his study in China, Kaō's paintings show none of the naiveté that might be expected of pioneer works: The brushwork is decisive, the ink tone skillfully varied, and the works full of life and energy. His paintings include *Han-shan* (an eccentric T'ang monk who is admired as an embodiment of the Zen ideal of freedom and childlike spontaneity; Plate 27); *Plum and Sparrows* (Plate 28), in which a tiny bird's upturned head conveys in a single gesture a sense of infinity and of fragile life in harmony with nature; and elegant landscapes (Plate 29).

Zen teaching stresses the very human struggle of Sākyamuni to achieve enlightenment by his own efforts, and the motif of Sākyamuni, bent on this quest, emerging from a period of austerities in the mountains is a recurrent theme in Chinese and Japanese ink painting. Plates 19 and 129 show some examples. Opinion is divided as to whether the descent from the mountains depicted in ink paintings comes after Sākyamuni's decision to abandon extreme asceticism in favor of the "middle way" but before his enlightenment or, as the nimbus, the protuberance on the head, and the concealed, folded hands suggest, sometime after his enlightenment. Whatever the precise moment, the carefully delineated, withdrawn expression, the half-closed eyes and downcast head, and the softly flowing lines of the robe all contribute to an impression of inner tranquillity and composure.

Compared with Plate 129, relatively little attention is given to detail in the delineation of the rather emaciated figure of Sākyamuni shown in Plate 19; more emphasis is placed on the use of space and modulation of line and ink shade. For Zen monks and ink painters, the plum, like the bamboo and the orchid, was symbolic of purity. Its indifference to the harshness of winter may also have influenced the choice of

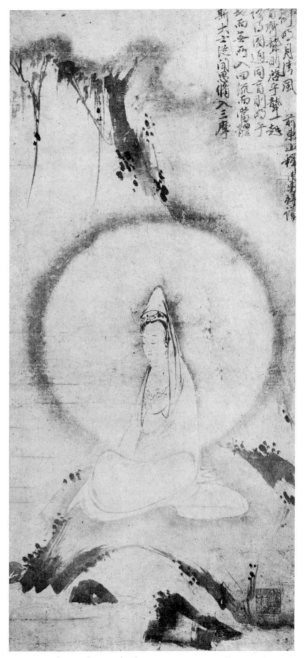

34. *Minchō:* White-robed Kannon. *Late 14th or early 15th century. Tokyo National Museum.*

35. Minchō: Shōichi Kokushi. *Late 14th or early 15th century. Tokyo National Museum.*

this subject for the flanking scrolls of this triptych.

The cheerful eccentric, recluse, and poet Han-shan shown in Plate 27 was said to have lived with his equally unconventional friend Shih-te in the T'ien-t'ai mountains, where they associated with the Zen master and poet Feng Kan (Plate 16). Han-shan was popularly accepted as an incarnation of the Bodhisattva Mañjuśrī, who is revered in Zen as the Bodhisattva of intuitive wisdom. As idealized examples of Taoist-Zen spontaneity and life style, Han-shan and Shih-te became extremely popular subjects with Chinese and Japanese ink painters. This painting by Kaō is a particularly fine example. The whole figure is painted with great authority—the head and feet in some detail,

the upper part of the robe in a few very powerful strokes, the lower part shaded in contrast. The swirl of the long sleeves, the relaxed but firm posture, and the whimsical expression all contribute to a sense of life and vitality (see also Plates 100 and 123).

The Zen monk Mokuan Reien (d. c. 1345) went to China not many years after Kaō, probably in 1326 or 1327, and there displayed such skill in painting (Plate 51) that he is said to have been regarded as a reincarnation of the Southern Sung master Mu Ch'i. This painting shows a Pu-t'ai-like Feng Kan, his tiger, and Han-shan and Shih-te all dreaming contentedly. Light ink tones predominate, and the composition is balanced and economical. Although the

painting gives an impression of rapid, almost casual brushwork, the faces of the figures are painted in some detail.

Although Mokuan did not live to return to Japan, his work did have an influence on the development of Japanese ink painting. Those of his paintings that were brought back to Japan were highly esteemed and had a profound effect on later painters, among them Hasegawa Tōhaku (1539–1610) and his school. Another Japanese monk of this early phase who voyaged to China and combined the study of Zen with that of ink painting was Tesshū Tokusai (d. 1336), the orchid specialist.

Zen monk-painters used brush and ink as an avocation, but it was not long before the professional Buddhist painters, drawn by the directness and simplicity of the new mode and responding to a new demand and taste, began to turn from color to ink, or to work in both media. Members of the progressive Takuma school, who had been *ebusshi* since the Heian period, were among the first to experiment with ink. The portrait of the Kegon-sect monk Myō-e Shōnin (1173–1232) seated in outdoor meditation (Plate 30) is thought to be a work of this school and displays, in its placement of the figure in a natural setting and in the free play of ink lines over the light color surface, the unmistakable imprint of ink-painting techniques. Although the attribution of this particular painting to the Takuma school may be open to question, there is no doubt that by the mid-fourteenth century Takuma Eiga and other members of the school were producing ink paintings.

It was also natural that the *ebusshi* among Zen monk-painters, those who specialized in colored votive paintings for such great Zen monasteries as Tōfuku-ji in Kyoto, should quickly take an interest in the new monochrome painting. Ryōsen of Tōfuku-ji, who was active at about the same time as Takuma Eiga, has left such ink paintings as the *White-robed Kannon* (Avalokiteśvara; Plate 32) and the *Kannon* shown in Plate 33. The paintings of Kichizan Minchō (1350–

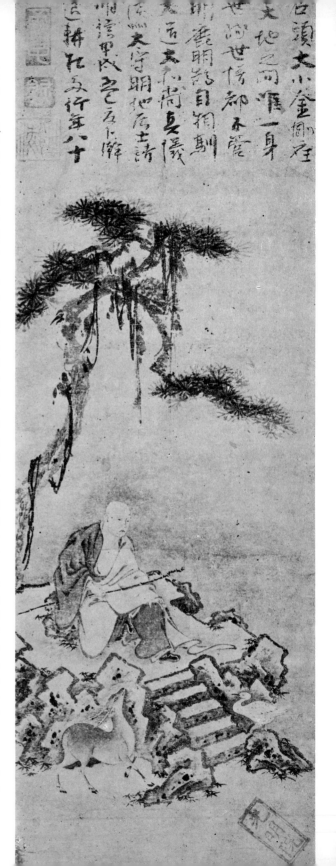

36. Daidō Oshō (1292–1370). Attributed to Minchō. Inscription by Shōkai Keiken (1315–96). Ink on paper; ht 48.2, w 16.5 cm. Dated 1394. Nara National Museum.

1431), the greatest and most prolific member of the Tōfuku-ji atelier, include an enormous (15 by 8 meters) deathbed scene, *Sākyamuni Entering Nirvana*, as well as paintings of the five hundred arhats, all done in vivid colors. Yet Minchō's ink sketch of Shōichi Kokushi, the founder of Tōfuku-ji and one of the Japanese pioneers of Zen (Plate 35), or the abbot Daidō Oshō, Minchō's own master at Tōfuku-ji, delivering an outdoor discourse (Plate 36), are pure ink paintings. In the painting of rock forms and foliage of the outdoor setting; in the relaxed posture, shape of the head, and fall of the drapery; and in the combination of an *ebusshi* concern for detail with *suiboku* brushwork and use of space, shade, and line, the ink sketch of the founder of Tōfuku-ji, even though posthumous, has much in common with the portrait from life of Daidō (Plate 36).

In the special realm of ink landscape painting, the *Cottage by a Mountain Stream* (Plate 37), painted in 1413 and attributed to Minchō, marked a major step forward. Minchō's landscapes owed much of their inspiration to the classical landscape styles that prevailed in the province of Chekiang, the region of China having the closest cultural ties with Japan at this time. However, his landscapes have some affinities to those of Fan K'uan (Plate 4) and Kuo Hsi (Plate 3) of the Northern Sung dynasty and therefore are rather different from those of the Southern Sung court landscape artists Liang K'ai, Ma Yüan, and Hsia Kuei. The works of these men were to become models for most Japanese painters of ink landscape after Minchō.

Chinese Models

A very precise picture of the nature and extent of Chinese influence on Japanese painting in the fourteenth and fifteenth centuries is provided by several documents of the day. For the earlier phase, the *Butsunichi-an Komotsu Mokuroku* (Catalog of Objects in the Butsunichi-an), compiled in 1320, lists and describes the art objects held by the Butsunichi-an, a subtemple

37. Cottage by a Mountain Stream. Attributed to Minchō. Inscriptions by Taihaku Shingen and six other monks. Ink on paper; ht 101.5, w 34.5 cm. National Treasure. Painted 1413. Konchi-in, Nanzen-ji, Kyoto.

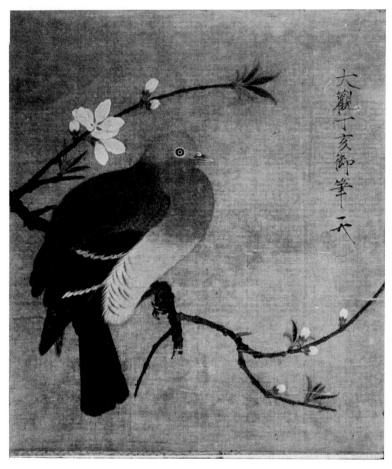

38. *Emperor Hui Tsung:* Peach Tree
and Dove. *Colors on silk; ht 28.5, w
27 cm. National Treasure. Northern Sung
dynasty, 1107. Iwao Collection, Kanagawa
Prefecture.*

of the Kamakura Zen monastery of Engaku-ji. The
temple held numerous objects imported from China,
especially ink paintings, samples of calligraphy, and
portraits of renowned Zen monks *(chinzō).*

Many Chinese paintings are also listed in the *Gyo-
motsu On'e Mokuroku* and the *Kundaikan Sōchōki,* rec-
ords compiled in large part by Nōami (c. 1394–1471)
and Sōami, father and son who were ink painters, con-
noisseurs of the arts, and cultural confidants to the
ruling Ashikaga shoguns (see Plates 108 and 111).
The *Gyomotsu On'e Mokuroku* catalogs the Sung- and
Yüan-dynasty paintings held by the Ashikaga sho-
guns, and lists ninety works made up into two hundred
and eighty scrolls. The *Kundaikan Sōchōki,* or what
remains of it, grades Sung- and Yüan-dynasty painters
into three categories (superb, accomplished, and in-

different), evaluates their paintings, and describes the
interior setting in which they could be best enjoyed.
Both works, in addition to giving precise information
about individual Chinese paintings in Japan in the
Muromachi period (1336–1568), provide interesting
insights into the nature and quality of Japanese appre-
ciation of these works. Specific Chinese ink paintings
are frequently mentioned in poems composed by
Japanese Zen monks from the *gozan* monasteries. They
are also listed in diaries such as the *Onryōken Nichiroku,*
of the abbot of the Onryōken, a subtemple of Shō-
koku-ji in Kyoto, the hub of the *gozan* system and
closest to the *bakufu* of all the *gozan* monasteries.

Among the imported paintings mentioned in these
works many, naturally, were painted by Zen monks
such as Mu Ch'i (Plate 52) and Chih Weng of the

Southern Sung and Yin T'o-lo of the Yüan dynasties. A large percentage of works were by Chinese court painters: landscapes and figures by Ma Yüan, Hsia Kuei, and Liang K'ai, and delicately colored works by Emperor Hui Tsung (Plate 38), who was famed for his realistic bird and flower paintings. The Japanese catalogs and records, however, make no mention of works by painters who were identified with the literati tradition. As the tradition came to be defined in the late Ming period, the literati *(wen-jen)* were amateur artists of high ethical and spiritual cultivation. Their poetry and painting were done not in a professional manner, but rather in the spirit of personal independence that had moved Wang Wei, the T'ang-dynasty poet-painter and semirecluse who was accepted as the legendary founder of the tradition. Individual artists of the later T'ang, Five Dynasties, and Sung periods, such as Tung Yüan, Chü Jan, Mi Fei, and Kao K'o-kung, were thought to express the *wen-jen* spirit. With the Mongol conquest of China and the occupation of the imperial throne by hated foreigners, the tendency of painters to withdraw from contact with court patrons and official society was increased in such men as Wang Meng, Wu Chen, and Ni Tsan. By the fifteenth century, the viewpoint of the literati had come to inspire virtually all the most gifted painters in China. These men began to establish a distinct pictorial style to embody a highly personal and deceptively unstudied aesthetic attitude.

In view of the surge of Zen development in Japan from the late thirteenth century on, it is easy to understand why paintings by Chinese Zen monks should have been in demand. And the works of Chinese court painters and emperors naturally appealed to the tastes and pretensions of Japanese courtiers and samurai. But how do we account for the almost total neglect of literati painting, one of the most vital art forms in contemporary China? One reason may have been because paintings by literati masters in China were usually painted not as a commercial product but privately for a particular client or patron. Perhaps, too, Japan was not quite ready intellectually for these very sophisticated works—or, more accurately, the Japanese had not yet become attuned to the aesthetic and intellectual qualities of a movement that in China was still in its formative phases. The traditions of Zen-related painting were well rooted and understood in the monasteries; the academy paintings, done for the most part by professional artists, were aristocratic and highly decorative and did not call for the philosophical and social grounding demanded for full appreciation of the literati tradition. Whatever the reason for the attraction to some types of painting and the neglect of others, the nature of the Chinese works introduced into Japan in the Muromachi period was decisive in setting the pattern for the development of Japanese ink painting for centuries to come.

3

The Shōkoku-ji Painters

Yoshimochi (1386–1428), the fourth Ashikaga shogun, was a devoted student of Zen and an accomplished ink painter. Under his patronage, painter-monks like Josetsu matured as *suiboku* artists. Although Minchō at Tōfuku-ji was still a major force in the opening years of the fifteenth century (see Plate 37) and artists like Gyokuen Bompō (Plate 40) and Gukei Jō-e (Plate 41) were also active, the Shōkoku-ji monk Josetsu is undoubtedly the outstanding figure of this phase of *suibokuga* development.

Josetsu

Josetsu's antecedents are shadowy. The two characters making up his name mean "clumsy-like" and appear in a phrase in the Taoist classic *Tao-te Ching* to the effect that great skill can look like sheer clumsiness. The name was bestowed on Josetsu by Zekkai Chūshin (1336–1405), abbot of Shōkoku-ji, an indication that Josetsu was already active as an ink painter at the turn of century in Zekkai's circle there.

The major circumstance in Josetsu's career was unquestionably Yoshimochi's commission to produce a painting on the *kōan*-like theme of how to master a catfish with a gourd (not, as is sometimes suggested, how to catch a catfish in a gourd). When the painting (Plates 43, 44, 56) was completed, Yoshimochi assembled some thirty of the most eminent Zen masters from the major Kyoto *gozan* monasteries and had each contribute an "interpretation" of the problem in verse. The painting originally decorated one face of a small standing screen of a kind commonly found in Zen

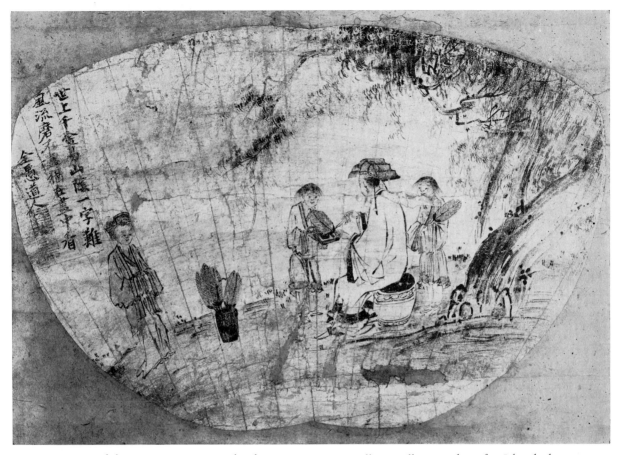

39. Wang Hsi-chih Writing on Fans. *Attributed to Josetsu. Hanging scroll, originally mounted as a fan. Ink and colors on paper; ht 98.3, w 21.8 cm. Important Cultural Property. Early 14th century. Agency for Cultural Affairs of the Japanese Government, Tokyo.*

monasteries. The verses were inscribed on a separate sheet of paper and attached to the reverse of the screen; only later were painting and verses joined in the vertical format of the hanging scroll that is so familiar today.

The monk Taigaku Shūsū (d.c. 1423), who contributed the first of thirty-one verses, described the occasion of the painting in a short preface: "Birds can be downed with slings. Fish can be trapped in nets. But how can one pin down a slippery, squirming catfish in the slime of a broad puddle with only a smooth, round, empty gourd? This is surely an impossible task. The taisōkō [shogun] had the monk Josetsu paint this theme in the new style on the small single-leaf screen which stands beside him and has asked various monks to add some spontaneous comments. Not in the least intimidated at being only a humble rustic, I [Shūsū] inscribe the first verse in sixteen characters."

> Poised! With the gourd
> He tries to pin that slippery fish.
> Some oil on the gourd
> Would add zest to the chase!

The other thirty poems are similarly cryptic and humorous. None provides an obvious answer, but taken together they suggest that the problem was conceived in terms of the mastery of man's wayward mind through dissolving the distinctions of self and other, catfish and gourd.

Josetsu is also accepted as the author of a painting on the theme of the Three Doctrines, personified in the persons of their founders—Confucius, Sākyamuni,

and Lao-tzu—and of a painting of the fourth-century Chinese calligrapher and storyteller Wang Hsi-chih (Plate 39). This carefully detailed work illustrates an anecdote in which the famous calligrapher put samples of his calligraphy on some old bamboo fans being sold by an illiterate woman (standing at left). Annoyance at what she thought was damage to her merchandise turned to delight when she discovered the market value of Wang's calligraphy. The theme has no particular connection with Zen but seems to have been illustrated by Chinese painters from an early period. An earlier version by Liang K'ai in the Palace Museum in Peking is strikingly similar to this one by Josetsu. The inscription on the left side of the painting is by Taigaku Shūsū, who inscribed Josetsu's *Catfish and Gourd*. It is written on a separate piece of paper and was probably moved to this position during the remounting. Above the painting (not visible in this illustration) is a long inscription by the monk Ishō Tokugan, who also contributed a verse to *Catfish and Gourd*, which attributes this fan painting to Josetsu and explains how much Taigaku Shūsū, the original owner of the fan, admired the painting.

On the basis of its style, *A Sage Admiring a Plum Tree* (Plate 45) is also attributed to Josetsu. Since all four works reveal the influence of the terse, elemental, Zen-inspired style of the Southern Sung master Liang K'ai (Plate 25), Shūsū's reference to Josetsu painting in a "new style" can probably be taken to mean that Yoshimochi, impressed with the work of Liang K'ai and Chinese paintings in the Liang K'ai manner which had been brought to Japan, wished Josetsu to produce something in the same style.

The only other item of documentary information we have about Josetsu is that he was sent by Yoshimochi to the island of Shikoku to select building materials for a pagoda to be built at Shōkoku-ji in honor of Musō Soseki (1275–1351), the monastery's official founder. In spite of the poverty of the documentary record, it is clear from the works themselves that Josetsu was an exceptionally gifted painter whose talents were appreciated and admired by the Ashikaga

40. *Gyokuen Bompō:* Wild Orchids. *Inscription by the artist. Ink on paper; ht 106.5, w 34.5 cm. Late 14th or early 15th century. Asano Collection, Tokyo.*

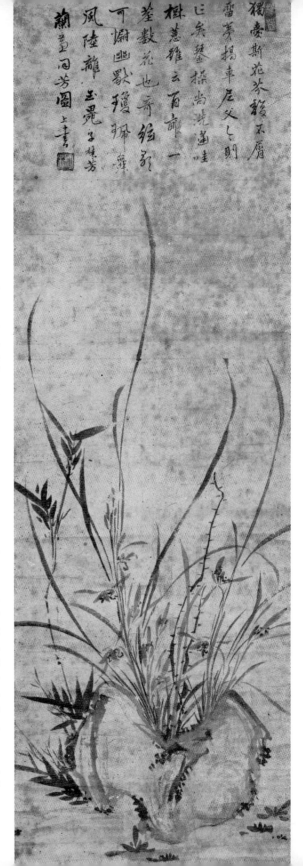

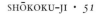

shoguns. Moreover, Josetsu was obviously instrumental in establishing Shōkoku-ji as the center of the "new style" of ink painting, and since he was followed there by the great painters Shūbun and Sesshū, Josetsu can fairly be described as the fountainhead of what was to be the mainstream of Muromachi-period *suibokuga*.

Taoist and Confucian Themes

In *Catfish and Gourd,* whether mounted as screen or scroll, artistic and literary content were clearly intended to find equal expression. The painting focused and illustrated the verses, which in turn extended and enriched the implications of the painting. There are a number of other works of the early fifteenth century in which painting and verse fuse to illuminate a single theme. These works, reflecting the close ties between literary *gozan* monks and ink painters, are collectively known as poetry and painting scrolls *(shigajiku).*

On the basis of their subject matter, they can be divided into several broad categories: *Cottage by a Mountain Stream* (1413; Plate 37), *The Retreat of the Three Worthies* (1418; Plate 55), and *Waterside Cottage* (1419; Plate 47) idealize the sequestered retreats and secluded life of Zen monks or scholars. Although the subject of *Waterside Cottage* belongs to the established tradition of paintings showing a scholar's retreat, according to one of the inscriptions, that by Ishō Tokugan (d. c. 1434), the painting depicts a scene well known to him: the view from a temple in the province of Settsu across the bay toward the island of Awaji. Early fifteenth-century landscapes were not so formalized that they rejected actual scenery, and it is perhaps the direct inspiration of nature which gives to this balanced, spacious painting much of its vitality and freshness.

New Moon over the Rustic Gate (1405; Plate 42) and *Banana Trees in Night Rain* (1410; Plate 46) derive from the poetry of Tu Fu, Wang Wei, and other Chinese literary masters. (The latter painting was produced during a literary gathering at Nanzen-ji to

41. *Gukei Jō-e:* Landscape. *Late 14th or early 15th century. Tokyo National Museum.*

42. *(left)* New Moon over the Rustic Gate. *Artist unknown. Inscriptions by Gyokuen Bompō and seventeen other monks. Ink on paper; ht 129.4, w 43.3 cm. National Treasure. Painted 1405. Fujita Art Museum, Osaka.*
43. *(right) Josetsu:* Catfish and Gourd. *Inscriptions by Taigaku Shūsū and thirty other Zen monks. Ink and colors on paper; ht 111.5, w 78.5 cm. National Treasure. Painted c. 1413. Taizō-in, Myōshin-ji, Kyoto. See also Plates 44, 56.*

44. Josetsu: Catfish and Gourd. *Detail. See Plates 43, 56.*

which members of a Korean delegation attending Yoshimochi's inauguration as fourth Ashikaga shogun in 1410 were invited.) *Turning Homeward out of Filiality* (1425; Plate 58) illustrates the popular Chinese literary theme of parting with friends. *A Sage Admiring a Plum Tree* (by 1413; Plate 45) is of Confucian inspiration, while *Catfish and Gourd* (after 1413) is Zen inspired.

Common to all these *shigajiku* is a literary flavor and the vigorous expression of Taoist-Confucian love of poetry, learning, and withdrawal from the bustle of the mundane world to self-reflection in the tranquillity of nature. This strong Taoist and Confucian coloration in an art form produced primarily in Buddhist monasteries by monk-painters reflects the influence of a current of thought, known as the Unity of the Three Doctrines, in which Confucianism, Taoism, and Buddhism were seen as simply different paths to the same goal.

The idea had deep roots in China, was espoused by many leading Zen monks during the Sung dynasty, and thereafter found widespread acceptance in Japanese Zen monasteries from the Kamakura period onward. The existence of this intellectual current helps to account for the fact that Zen Buddhist monks like I-shan were among the first to introduce Neo-Confucian ideas to Japan. Moreover, the unity-of-doctrines idea was an important support for the *gozan* literary movement, which could hardly have developed had Zen monks confined their reading to the biographies and *kōan* of Zen patriarchs or to Buddhist sutras. The synthesis also allowed Zen monk-painters to incorporate non-Buddhist themes in their work. Gidō Shūshin (1325–88), for instance, who was at different times abbot of the prestigious Kyoto *gozan* monasteries of Kennin-ji and Nanzen-ji and who bitterly lamented the fact that most Zen monks of his day were more attracted to Taoist and Confucian classics than they were to Buddhist texts, was himself a major figure in the *gozan* poetry movement and an eager student of Chinese classical literature. Other leaders

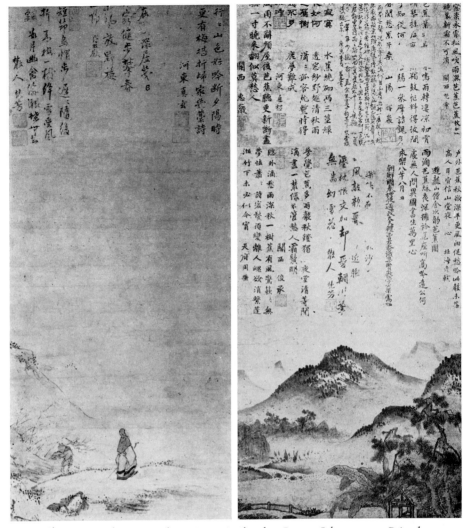

45. (left) A Sage Admiring a Plum Tree. *Attributed to Josetsu. Ink on paper. Painted c. 1413. Sekizumi Collection, Tokyo.*

46. (right) Banana Trees in Night Rain. *Artist unknown. Fourteen inscriptions. Ink on paper; ht 96, w 31.4 cm. Important Cultural Property. Painted 1410. Hinohara Collection, Tokyo.*

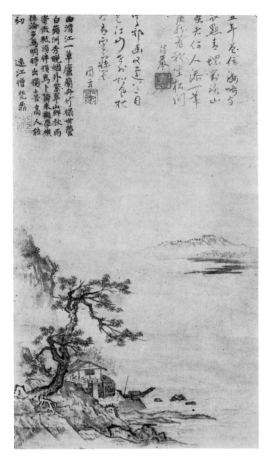

47. Waterside Cottage. *Artist unknown. Inscriptions by Taigaku Shūsū and eleven other monks. Ink and colors on paper; ht 103.6, w 33.9 cm. Important Cultural Property. Painted 1419. Nezu Art Museum, Tokyo.*

of the *gozan* literary movement, men like the monk and poet Zekkai Chūshin or the poet and painter of orchids Gyokuen Bompō, also found literary and artistic inspiration in the Taoist and Confucian traditions, even forming a literary circle calling itself The Companions of Letters.

One of the earliest expressions of the unity-of-doctrines synthesis in Japanese painting is the theme of Kitano Tenjin in China. Tenjin, "heavenly being," was originally the early Heian-period scholar-poet and statesman Sugawara Michizane (845–903), who ended a brilliant career in political disgrace and exile. A series of natural disasters following his death were taken as evidence of his desire for revenge on society and on the ruling Fujiwara family for the unjust treatment of an innocent man. The unhappy career of Michizane touched popular sympathies, and his spirit came to be venerated as a Shintō deity at the great Kitano shrine in Kyoto first as a guardian deity against fire and flood, and later as a divine patron of poetry and learning. *Gozan* monks carried the legend even further by creating a tradition that Tenjin visited China, studied Zen with the abbot Wu-chun Shih-fan at his monastery on Mount Ching near Hangchow, and there attained enlightenment. Through this legend the native Japanese poetry tradition, of which Tenjin was a prime symbol, was grafted onto the tradition of Chinese poetry that was the heart of the *gozan* literature.

As a personification of doctrinal accommodation, Michizane is shown in Plate 48 in Chinese Confucian costume, wearing the stole of a Zen monk and carry-

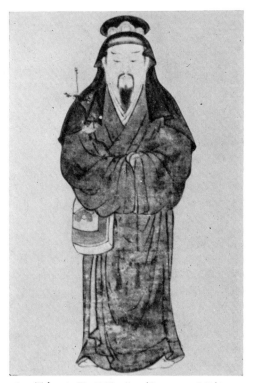

48. *Tokusei:* Totō Tenjin *(Sugawara Michizane in his deified form as Tenjin crossing to China). Inscription by Setsurei Eikin. Late 15th or early 16th century. Tokiwayama Collection, Kamakura.*

ing his favorite flower, a sprig of plum blossom. The historical Michizane probably knew little of Zen, and far from visiting China, was, ironically, responsible for bringing to an end more than two centuries of official Sino-Japanese intercourse. In 894, he declined the request to lead a mission to China on the grounds that disruption and decline of the T'ang empire and the proven dangers and difficulties of the voyage were likely to render such missions fruitless.

Other expressions of this synthesis are *The Three Sages* (see Plate 71), showing Confucius, Sākyamuni, and Lao-tzu together; or *The Three Tasters of Vinegar* (Plate 49), with representatives of the three doctrines in perfect wry-faced sympathy as they sip vinegared wine from the same jar. Another variant is *The Three Laughers of Tiger Ravine* (Plate 50), which shows the famous fourth-century monk Hui Yüan, the poet T'ao Yüan-ming, and a Taoist sage, Lu Hsiu-ching, laughing together when they realize that Hui Yüan, in his pleasure at their meeting and reluctance to part from them, has inadvertently broken his solemn vow never to leave his monastery and cross its boundary, Tiger Ravine, into the secular world. In another version of the theme, the three doctrines are likened to three trees—pine, plum, and bamboo—that are companions in winter and of the scholar-recluse. Works illustrating all these themes were frequently painted throughout the Muromachi period.

The theme of the unity of the three doctrines is also latent in the many landscape paintings that idealize a secluded, scholarly life of study and reflection far from the vicissitudes of politics, the whirl of social

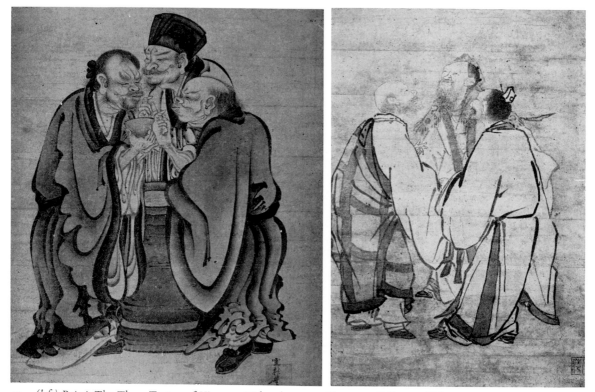

49. (left) Reisai: The Three Tasters of Vinegar. Mid-15th century. Umezawa Collection, Tokyo.
50. (right) Bunsei: The Three Laughers of Tiger Ravine. Ink on paper; ht 56.8, w 31.8 cm. Mid-15th century. Powers Collection, New York.

activity, or the demands of family—and far too from the bustling halls of the great metropolitan Zen monasteries. This ideal of withdrawal was not new. In China, it had been discussed and rejected in the *Analects* of Confucius but became a recurrent counterpoint to the Confucian ideal of service to the state. Advocated by Lao-tzu and Chuang-tzu, it became one of the major strands in Taoist thought. It also permeated Zen thinking and stirred some of the finest Chinese poets; it was, in fact, so pervasive in Chinese intellectual life that accommodation had also to be made for it in painting.

In the traditional Chinese categorization of paintings into "divine," "mysterious," "skillful," and "untrammeled," pride of place came to be given to works in the *i-p'in* or "untrammeled" category. These works,

frequently painted by Zen monks who lived in virtual seclusion, were admired both because they were felt to be unworldly and concerned with the spirit rather than the mere form of things and also because they were painted by men bent on a solitary quest for self-understanding. Such men shunned society and painted not as professionals, but out of inner compulsion as an expression of deep spiritual insight. Most of the works in the "untrammeled" category were in ink, which seemed best to lend itself to the expression of mystical or intuitive perception of inner reality.

The ideal of withdrawal was also prevalent in Japanese Zen monasteries and ink-painting circles. It was realized by the monk Jakushitsu Genkō (1290–1367), who accompanied Kaō to China in 1320 and later established the rural monastic retreat of Eigen-ji at

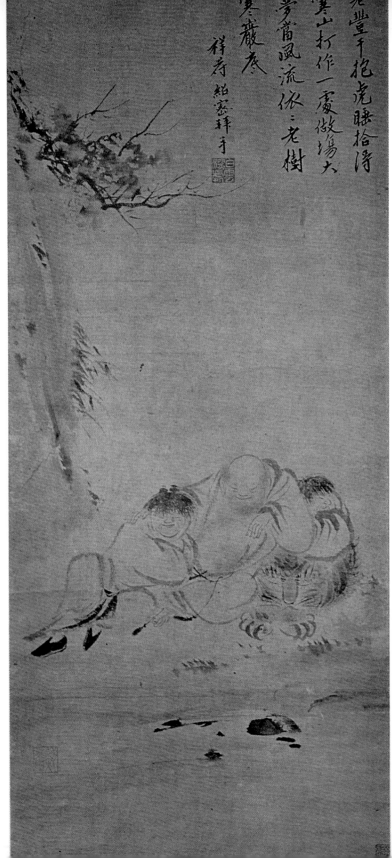

51. *Mokuan Reien:* The Four Sleepers.
Ink on paper; ht 73, w 32.2 cm. Inscrip-
tions by Hsiang-fu Shao-mi. Han-shan and
Shih-te, one of the favorite subjects of Zen
painters, are gathered here with Feng Kan
and his tiger, all four sleeping peacefully.
Mokuan has depicted a feeling of blissful
contentment with light ink tones and created
an interesting composition in which the
flow of the lines of the cliff and the branch
sloping to the right are balanced by the
form of the tiger. The artist himself never
returned to Japan from China, where he
had gone to study and where he had met
with great acclaim, but those of his works
that were brought back to Japan influenced
later Japanese suiboku painters. Early 14th
century. Maeda Foundation, Tokyo.

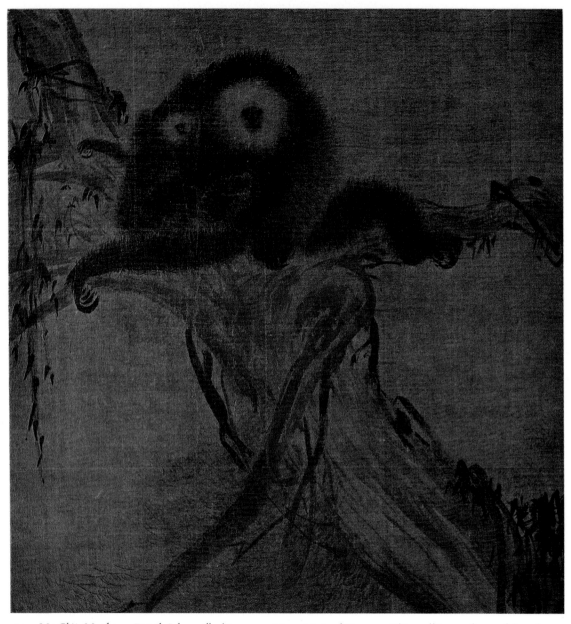

52. *Mu Ch'i: Monkeys. Detail. Ink on silk; ht 174, w 98.8 cm. National Treasure. This scroll is one of a set of three show-ing a white-robed Kannon flanked on one side by a crane and on the other by these monkeys. Characteristics of Mu Ch'i's work evident in this painting are skillful layering of ink to give a sense of depth and volume and an ability to convey reality through what at first sight seems rough and casual brushwork. Sesshū, Oguri Sōtan, Hasegawa Tōhaku, and many other Japanese suiboku painters were deeply influenced by the Mu Ch'i style. Southern Sung dynasty, late 12th century. Daitoku-ji, Kyoto.*

53. *Yi Su-mun (Ri Shūbun):* Bamboo against the Moon. *From the Ink Bamboo Painting Album. Ink on paper. Early 15th century. Take-koshi Collection, Hyōgo Prefecture.*
54. *Yi Su-mun (Ri Shūbun):* Landscape with Figures. *Early 15th cen-* ▷ *tury. Kusaba Collection, Tokyo.*

Omi on the edge of Lake Biwa. Jakushitsu, who loved painting, spent most of his life in the depths of the country, avoiding contact with the *gozan* and declining shogunal favors. He left as his testament the phrase: "Pure are the bones buried under rocks and roots." Gyokuen Bompō rose to be abbot of several *gozan* monasteries but eventually, rejecting the abbacy of Nanzen-ji, withdrew to die in the seclusion of a hut in the wilds at Omi. For Bompō, the orchids he loved to paint were symbolic of the purity of nature, its fragrance and tranquillity and unceasing attraction. Other monks, for whom retreat to a solitary life in nature was impossible, responded emotionally to the ideal as it was voiced in poems and paintings.

The statement that Josetsu painted in the Liang K'ai style requires some qualification. Many of the land-

scapes of this period, especially those in the form of poetry and picture scrolls, are laterally expansive. The traditional norms of Chinese ink painting stress the mastery of three spatial dimensions: breadth, depth, and height. To be described as accomplished, a landscape painting had to be endowed with all three dimensions. In Josetsu's *Catfish and Gourd,* for instance, there is ample sense of breadth and depth but a rather inadequate sense of height. By classical Chinese standards, this painting and others of the period sharing this characteristic would probably be described as immature. As compensation, however, these works, when compared with many of the paintings of the Shūbun and post-Shūbun eras, when the norms of landscape had hardened and were meticulously observed, seem spontaneous and untrammeled by ex-

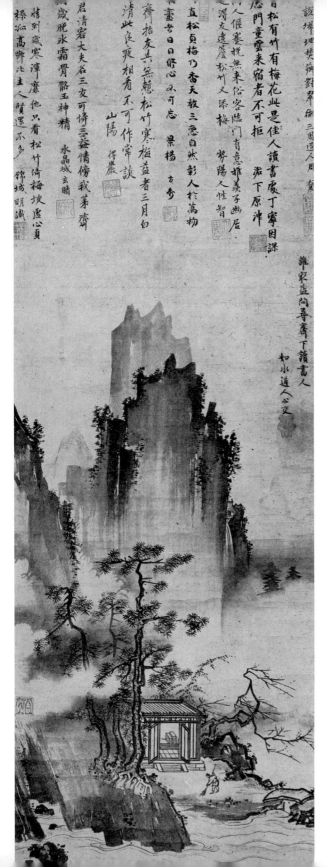

cessive formalism. It is to Shūbun, Josetsu's student at Shōkoku-ji, that we now turn.

Shūbun

Shūbun's life is only sketchily documented. Known also as Tenshō and Ekkei, he held the office of bursar *(tsūsu)* in the Kyoto monastery of Shōkoku-ji, where it is likely that he studied painting with Josetsu. Shūbun was obviously a man of many talents. His important position in charge of the business affairs of one of the most powerful of the *gozan* monasteries implies considerable administrative aptitude, and his artistic talents found expression in sculpture as well as in painting. Indeed, there is more contemporary documentary reference to Shūbun the sculptor than to Shūbun the painter. The *Onryōken Nichiroku,* for instance, describes his repairing a statue of Bodhidharma for the Daruma-ji in Nara and making a triad of Amida and the Bodhisattvas Kannon and Seishi for the Ungo-ji in Kyoto.

Mention of Shūbun the painter is more fleeting. In the journal of Prince Fushimi Sadafusa, the *Kammon Goki,* there is an entry stating that in 1438 Shūbun painted plum trees on some sliding door panels *(fusuma).* Apart from this reference, there are a few scattered mentions of his paintings in poems by *gozan* monks. That Shūbun, like Josetsu, had close ties with the Ashikaga shogunate through Shōkoku-ji and was probably a commissioned painter *(goyō eshi)* whose talents were recognized and well rewarded is indicated by the fact that Oguri Sōtan (1413–81), probably Shūbun's immediate successor as shogunal painter, was, on appointment, granted the same stipend as Shūbun.

In 1423 Shūbun visited Korea. Japanese documents are silent on this journey as on so much about him, but his name appears in the *Official Record of the Yi Dynasty* as a member of a Japanese embassy sent to Korea in quest of a block-printed edition of the Buddhist canon. Although it is unclear how old Shūbun was at this time, the responsibility of the role implies that he had

55. The Retreat of the Three Worthies. *Attributed to Shūbun. Inscriptions by Gyokuen Bompō and eight other monks. Ink on paper; ht 110.5, w 38.8 cm. Dated 1418. Seikadō Foundation, Tokyo.*

56. *Josetsu: Catfish and Gourd. Detail. Inscriptions by Taigaku Shūsū and thirty other monks. Ink and colors on paper; ht 111.5, w 75.8 cm. National Treasure. Yoshimochi, the fourth Ashikaga shogun, commissioned the Shōkoku-ji monk-painter Josetsu to illustrate the kōan-like allegory of how to master a catfish with a gourd. An inscription above the painting states that it was painted in the "new manner," implying perhaps conscious use of the Liang K'ai style or a new combination of zenkizu theme with landscape setting. See also Plates 43, 44. Painted c. 1413. Taizō-in, Myōshin-ji, Kyoto.*

57. *Sesshū Tōyō: Haboku Landscape. Detail. Ink on paper; ht 147.9, w 32.7 cm. National Treasure. This* haboku *or "splashed* ▷
ink" landscape was painted when Sesshū was in his mid-seventies. It was inscribed by the painter and given to his pupil, the Kamakura monk Sōen. In the rapidly executed haboku, *the painter first uses a thin wash of ink to suggest the outline of a landscape, then adds touches of darker ink to the still-wet wash to introduce hints of detail. The focus of darker ink at the center of this painting prevents the composition from dissolving and adds weight and depth, while movement toward the lower right-hand corner relieves absolute verticality without in any way diminishing the impression of height. See also Plate 70. 1495. Tokyo National Museum.*

58. Turning Homeward out of Filiality. *Attributed to Shūbun. Ink on paper. Painted 1425. Tokiwayama Collection, Kamakura.*

completed his Zen training. The fact that Japanese records make no mention of the trip suggests that he had not yet established himself as a major painter in Japan. It was customary to send artists and men of culture on such embassies; Sesshū, for example, was later to make a similar journey to China. They went for two reasons: to participate in the exchange of diplomatic courtesies and to further their own art. Shūbun no doubt hoped to learn much from observation of Korean painters who had more direct exposure to Sung and Yüan painting than Japanese painters.

On the return voyage Shūbun may have been accompanied by the Korean painter Yi Su-mun who,

as artist in residence to the Asakura daimyo family of Echizen in central Japan, was to play an important role in the development of Japanese ink painting. Yi influenced the Soga family of Japanese painters and is sometimes described as the founder of the Soga school. Certainly, strong, clear lines of the type he favored are a characteristic of the Soga style. Until quite recently, however, the identity of Yi Su-mun was a complete mystery. Paintings bearing the three characters of the name, which in Japanese is pronounced Ri Shūbun, existed, and their style suggested that he was not Japanese (see, for example, Plate 54). But from the paintings and signatures

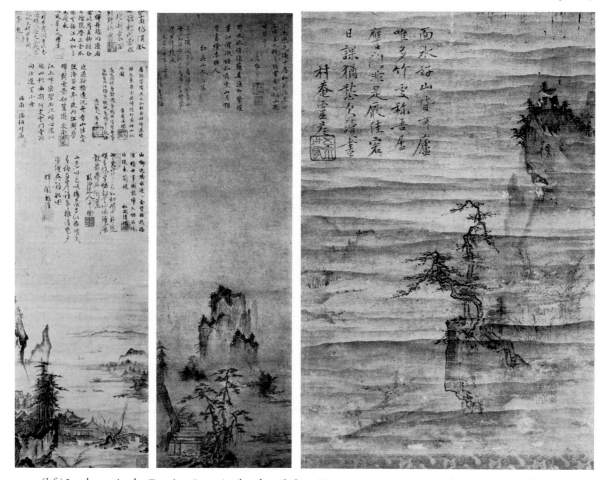

59. (left) Landscape in the Evening Sun. *Attributed to Shūbun. Ht 130.3, w 30.3 cm. Painted 1447. Kosaka Collection, Tokyo.*
60. (center) Color of Stream and Hue of Mountains. *Attributed to Shūbun. Painted 1445. Fujiwara Collection, Tokyo.*
61. (right) Study in a Bamboo Grove. Detail. *Attributed to Shūbun. Painted c. 1446. Tokyo National Museum.*

alone it was impossible to tell whether he was Chinese or Korean, or precisely when he came to Japan. The recently discovered *Ink Bamboo Painting Album* (Plate 53), however, in addition to paintings of bamboo by Su-mun which are clearly in the Korean style, includes an autobiographical note stating that he came to Japan in 1424. Since Shūbun also returned in this year, it is possible that they traveled together and that Shūbun's visit to Korea may even have prompted Su-mun's visit to Japan.

Shūbun left the world as unobtrusively as he had entered it. In spite of his fame, there is no record of his death. The last painting attributed to him is dated 1447. If, in fact, Sōtan was Shūbun's immediate successor as shogunal *goyō eshi*, then we can assume that Shūbun died not long before 1463, when Sōtan was granted the retainer's stipend. And if Shūbun was already active as a painter when he made his journey to Korea in 1423, this would give him a forty-year period of activity covering most of the first half of the fifteenth century.

Although at least a score of existing paintings are attributed to Shūbun and many of them bear a Shūbun seal, it is impossible to state categorically that even one of these works was definitely painted by Shūbun. Much of the difficulty of positive identification is

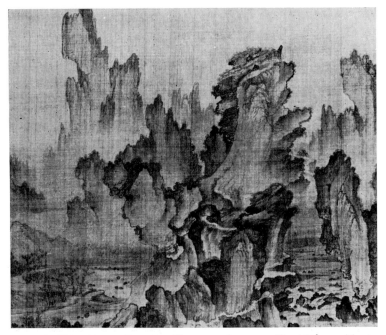

62. An Kyon: Dream Journey. *Korean, 15th century. Tenri Library, Tenri.*

63. (left) Landscape. *Shūbun school. 15th century. Seattle Art Museum.* ▷
64. (center) Landscape. *Shūbun school. 15th century. Yamamoto Collection,* ▷
Tokyo.
65. (right) Landscape in Ssechwan. *Shūbun school. Ink and colors on paper;* ▷
ht 74.3, w 30.3 cm. Painted c. 1446. Seikadō Foundation, Tokyo.

caused by the dearth of contemporary references to his paintings. Moreover, in Shūbun's day it was not yet customary for painters, especially monk-painters, to add a signature or seal to their work. Seals bearing the characters "Shūbun" were almost certainly imprinted later by owners who wished to lend authenticity to paintings which they believed to be by Shūbun. The problem of attribution in Shūbun's case is thus very acute, and the best that can be done at present is to attribute to him works known to have been produced in the period when he was probably active as a painter which seem appropriate to his reputation and what is known of his style.

Among the paintings most confidently attributed to him are these: *The Retreat of the Three Worthies* (1418; Plate 55), *Turning Homeward out of Filiality* (1425; Plate 58), *Landscape in the Evening Sun* (1447; Plate 59), *Color of Stream and Hue of Mountains* (1445; Plate 60), and *Study in a Bamboo Grove* (1446; Plate 61). But even making allowance for the thirty-year time span within which these five paintings were produced, they display such marked differences in style that it is almost impossible to believe they are the work of the same hand. Even the latter two works, which are held to be most characteristic of Shūbun and were produced within a few years of each other, differ considerably in style and brush technique.

Notwithstanding these differences, common features can be observed among the attributed paintings.

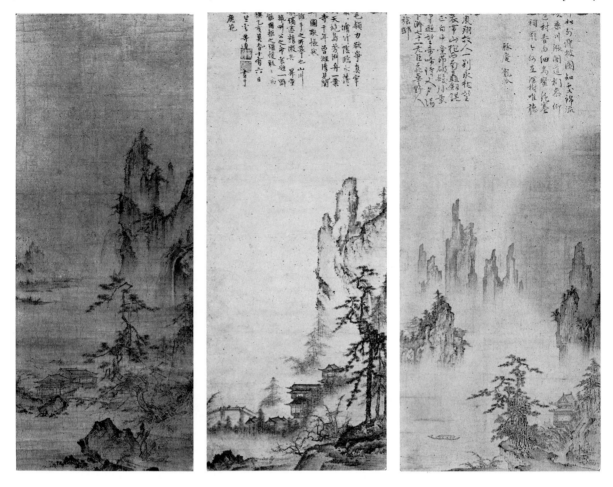

Unlike the rather broad vistas of the landscapes of the early years of the century, those attributed to Shūbun are all vertical compositions—narrow segments literally cut from nature, emphasizing the impression of height of mountain scenery. In the paintings of mountain scenery, jagged lines and ax-stroke notches produce soaring needles and spars of rock, and for the trunks and branches of trees the dominant lines are sharp zigzags. These techniques are characteristic of Ma Yüan and his son Ma Lin of the Southern Sung court academy, and their frequent use in Japanese painting of the mid-fifteenth century reveals the extent to which the style of these two Chinese painters was a favored model for Shūbun and members of his school. However, Shūbun's obvious liking for jagged,

vertical rock formations may also have owed something to his visit to Korea and the sight of rough Korean mountain peaks, or to the Korean landscape transposed into art in such landscape paintings as *Dream Journey* by An Kyon (Plate 62).

While the dramatic mountain forms painted by Shūbun and his followers were novel to Japan, these works lack something of the directness and vitality found in paintings of the early part of the century. Elegant and refined in technique, Shūbun-style landscapes are more like formalized designs based on Chinese or Korean models, divorced from the warmth and reality of natural scenery; see, for example, Plates 63, 64, 65. Irrespective of their quality, however, the fact that a painter of Shūbun's stature popularized

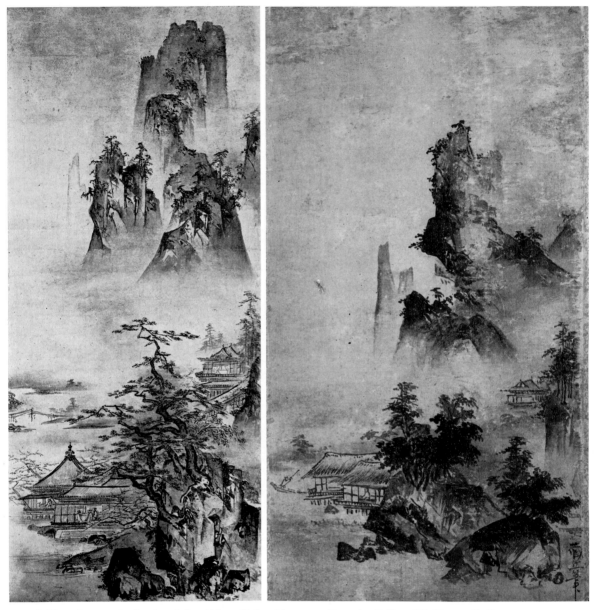

66. *(left)* Landscape. *Attributed to Gakuō Zōkyū. Early 16th century. Freer Art Gallery, Washington, D.C.*
67. *(right) Gakuō Zōkyū:* Landscape. *Ink on paper; ht 135, w 33.3 cm. Early 16th century. Tokyo National Museum.*

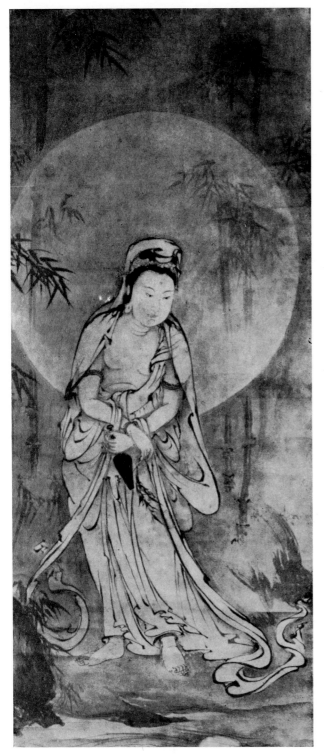

this style in Japan determined the direction of much of subsequent Japanese landscape painting; and through his own work and his influence on others, Shūbun too played a major role in establishing Muromachi *suibokuga*.

Many painters active in the second half of the fifteenth century have been described as Shūbun's disciples; among them are Sesshū, Gakuō, Shōkei, Sōtan, Soga Jasoku, Bunsei, and Nōami. Most of these painters, however, while learning from Shūbun, went on to establish their own very individual styles. Only Gakuō Zōkyū and Ten'yū Shōkei, who were Zen monk-painters in the traditional mold, faithfully carried on and extended the style of Shūbun. Gakuō's work is distinguished by its gentle tone, supple brushwork, delicate coloring, and rather greater faithfulness to natural scenery than Shūbun's paintings (Plates 66, 67, 68). Shōkei, whose paintings tend to be broader in scale than those of Shūbun, was a master of closely detailed descriptive landscape.

Shūbun's development of painting in the "new style" initiated by Josetsu at Shōkoku-ji ensured that monastery's dominance in ink painting for most of the fifteenth century. The importance of Shōkoku-ji is underlined by the facts that Sesshū was in the direct line of descent from Josetsu and Shūbun and that the Daitoku-ji painters, including Jasoku and Sōtan, were strongly influenced by Shōkoku-ji painters.

68. Water and Moon Kannon. *Attributed to Gakuō Zōkyū. Early 16th century.*

Sesshū

With Sesshū Tōyō (1420–1506), Japanese ink painting reached maturity. Sesshū's greatness lay in a robust, individual style that was founded squarely on assured mastery of the whole range of Chinese ink-painting techniques. A journey to China in middle age confirmed his confidence in his own abilities and lent authority to his reinforcement of Japanese self-confidence in *suibokuga*. Sesshū's insistence upon direct contact with nature brought ink painting down to earth and showed Japanese painters that their imaginations could be fired as well by the contours of their own mountains and valleys, temples, and villages as by the imaginary scenes of misty peaks and mountain hermitages of southern China. His paintings, marked with all he had learned and all he had discovered, set *suibokuga* on an ever more distinctive course.

Sesshū the Monk

Sesshū's long life straddled most of the turbulent fifteenth century. He was born into a warrior family of middling status and limited means, the Oda of Bitchū Province (present-day Okayama Prefecture). Provision was made for the boy to follow a path well trodden by the younger offspring of warrior families who were unable to provide much of a patrimony for their sons or support them in indolence; he was registered as a monk.

The Oda were overseers of lands held by Shōkoku-ji, and through this connection Sesshū was registered as a novice of that monastery when he was eleven or twelve. He did not immediately enter Shōkoku-ji and it is not clear when he first went to Kyoto, but he

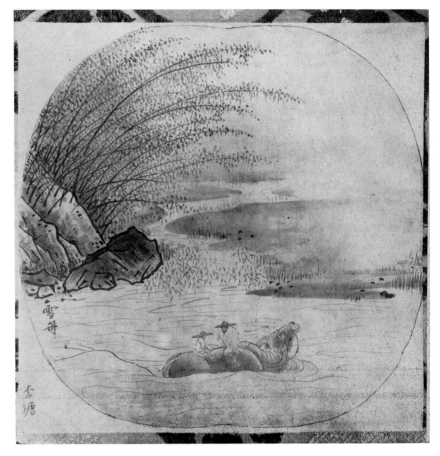

69. *Sesshū Tōyō:* Herdsmen and Water Buffalo. *After Li T'ang. Ink and colors on paper; ht 33.5, w 31.5 cm. Late 15th century. Asano Collection, Tokyo.*

is known to have studied Zen under Shunrin Shūtō, who was abbot of Shōkoku-ji while Sesshū was in his twenties and early thirties. Moreover, since Sesshū claimed Shūbun as his teacher, he must have been at Shōkoku-ji some time before Shūbun's death about mid-century. Under Shūbun's guidance, Sesshū began a quest to make Zen and painting one, a quest which was to make him a wanderer for most of his life, but was also to produce some of the finest of Japanese paintings.

When the young Oda entered Shōkoku-ji, he did not yet have the familiar name (or *azana*) Sesshū, which he adopted much later. He entered under the *imina,* or formal name, Tōyō, given to him when he enrolled as a novice. Throughout his monastic life at Shōkoku-ji he was known either as Tōyō or as Yō-shika—that is, Yō the Guest Master (the *yō* being the final character of Tōyō). In adopting an *azana,* it was the custom in Zen monasteries for the master to select and bestow a character compound that he felt complemented the monk's *imina,* or for the monk himself to select a pair of characters that appealed to him and then seek the approval of his master to use them as his *azana.* Tōyō followed the latter course. When he was forty-three or so he was given a sample of calligraphy by the Yüan Zen monk Ch'u-shih Fan-ch'i bearing the characters for "snow" and "boat." The resonances of this combination appealed to Tōyō, and he asked Ryūkō Shinkei, his Zen mentor, to confer them on him as an *azana.* In Japanese reading, the name is pronounced Sesshū, and henceforward he was known as Sesshū Tōyō. The problem of names and

◁ 70. *Sesshū Tōyō:* Haboku Landscape. *Detail, showing inscription by Sesshū.* Ink on paper; ht 147.9, w 32.7 cm. 1495. Tokyo National Museum. See also Plate 57.

identification is compounded by the fact that there are also paintings done by an artist who used the name Sessō Tōyō (triptych, Plate 71). Since nothing is known about a Sessō Tōyō, it has been suggested that Sessō and Sesshū are one and the same, and that the name Sessō is one Sesshū used until he adopted the *azana* that is now so famous.

The fact that in monastic documents Sesshū is commonly referred to as Yō the Guest Master implies that he never rose above this responsible but rather lowly office, and there are grounds for assuming that this may have rankled and contributed to his departure from Shōkoku-ji, for it is known that he had established himself near Yamaguchi by about 1464. The summit of worldly achievement for a Zen monk was to become the abbot of one of the *gozan* monasteries,

but at a time when, even in Zen circles, cliques and factions were rife, these positions went to monks who were related to or had the support of powerful provincial military rulers (daimyo) or to scions of the aristocracy. Without such connections, there was little hope of advancement; and Sesshū, the son of an insignificant provincial family, may have felt that his chances of ever rising higher in the monastic hierarchy were slim.

Sesshū in China

A sense of frustration may have caused him to pour more of his energies into painting than into Zen practice and may have prompted his departure from Shōkoku-ji. It is, of course, quite possible that Sesshū

71. *Sessō Tōyō:* The Three Sages. *Hanging scroll triptych. Ink on paper; ht 33, w 46 cm each. Late 15th century. Museum of Fine Arts, Boston.*

72. *Sesshū Tōyō:* Winter Landscape. *One of a pair of sixfold screens. Ink and colors on paper; ht 179.1, w 365.7 cm. Late 15th century. Kosaka Collection, Tokyo.*

73. *Sesshū Tōyō:* Landscape of the Four Seasons. *Detail. Ink and colors on paper; horizontal scroll; ht 39.7, w 1586 cm. National Treasure. This magnificent scroll, perhaps Sesshū's greatest work and the summation of a life devoted to* suiboku *and Zen, was painted at his private studio, the Unkoku-an in Suō, after his return from China. Starting with spring, the scroll follows the progression of the*

had no such worldly ambition, that he was content to perform his duties faithfully and devote himself to painting in the spirit of Zen practice, and that when he left Shōkoku-ji it was for other reasons. That he was disappointed at not rising higher in the Shōkoku-ji hierarchy, however, is suggested by his reaction to his reception in China, when he later visited the great Zen monastery of Ching-te on Mount T'ien-t'ung near the southern port city of Ssuming (Ningpo). There he was given a memorial certificate stating that he had held the First Seat (second only to the abbot) in the Monks' Hall.

No doubt this certificate was given to him as something of a diplomatic formality, but Sesshū was inordinately proud of this title and later often signed his work "Occupant of the First Seat at T'ien-t'ung in

Ssuming." The fact that in Shōkoku-ji he had been only guest master whereas in the very homeland of Zen and in one of China's leading monasteries he had achieved high office, however fleetingly, was obviously a source of great pride to Sesshū, and his frequent use of his honorary title may perhaps be seen as an implied protest at his treatment in Shōkoku-ji.

Sesshū made his journey to China in 1467. At this time the Muromachi *bakufu* and such major daimyo in the Inland Sea area as the Ouchi and Hosokawa were sending fairly frequent trade and diplomatic missions to Korea and Ming China. As a Zen practitioner and painter Sesshū was naturally eager to visit China, and one of his motives in leaving Shōkoku-ji and establishing the studio-retreat called the Unkoku-an in Suō near the Ouchi seat of power in Yamaguchi was the

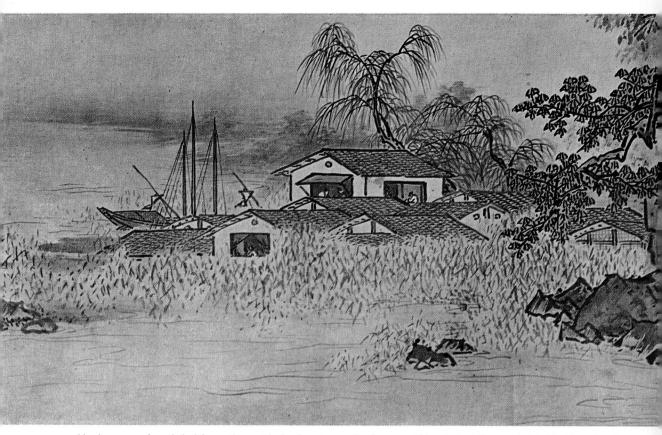

seasons, blending scenes from daily life in China with the changing moods of nature. Although the influence of Hsia Kuei is evident in the painting of the rocks and trees, the harmonious interweaving of the human world with the changing world of nature derives from Sesshū's own deep Zen Buddhist insight. 1486. Mōri Foundation, Bōfu, Yamaguchi Prefecture.

hope of thus introducing himself into one of the embassies. He was successful. The embassy he journeyed with sailed to Ningpo in southern China, and from there he traveled north to Peking.

While in Peking he was asked to do a painting on a wall panel in the Board of Rites, a building in which examinations for the Chinese civil service were held. The painting is said to have been lavishly praised, and it is alleged that aspirants to the Chinese bureaucracy were confronted with Sesshū's painting and told to strive in their studies lest they be shamed by the visitor from backward Japan. If this story is true, it indicates that Sesshū's talents as a painter were recognized by the Chinese and that his role was as much that of cultural emissary as Zen monk.

It is not clear exactly how long Sesshū stayed in China, but he was back in Japan by the beginning of 1469. Even before leaving Shōkoku-ji Sesshū had become well known in Japanese Zen circles as a talented painter. The journey to China added new depth to his work. Shūbun's reliance on imported Sung and Yüan paintings as models had given his paintings an ethereal, insubstantial quality. Under Shūbun's influence, Sesshū too had been content to imitate Chinese models (Plates 69, 75). His experience in China, however, led him toward a more idiosyncratic style grounded in direct observation.

In the inscription above the *Haboku Landscape* (see Plates 57, 70), painted shortly after his return, he describes his impressions of China and what he had learned from the experience: "I did not find in China many painters worthy of admiration or emulation.

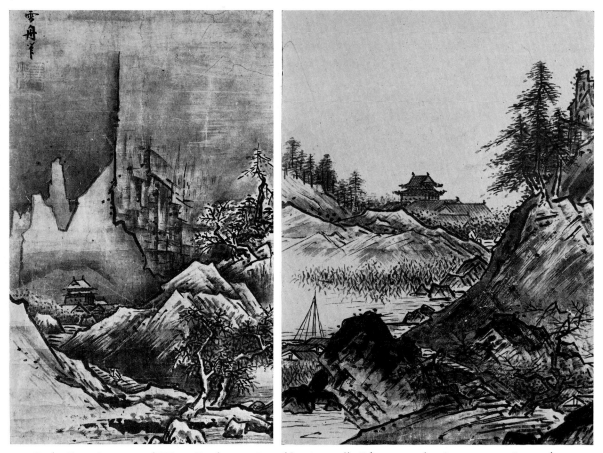

74. *Sesshū Tōyō:* Autumn and Winter Landscapes. *Pair of hanging scrolls. Ink on paper; ht 46.3, w 29.3 cm. Late 15th century.* Tokyo National Museum.

The Chinese landscape and the customs of the people, however, taught me much. Two of the most re-nowned masters of painting were Chang Yu-sheng and Li Tsai. From Chang I learned something of the use of color and from Li something of the use of ink. On the whole, however, my journey brought home to me for the first time the greatness of my own teachers Shūbun and Josetsu." Sesshū's statement that nature and the customs of the Chinese people were his best teachers is important as a deliberate rejection of painted models in favor of direct experience of the vastness and structural complexity of natural land-scape. His acceptance of direct experience marked the true foundation of landscape painting in Japan.

Sesshū broke new ground in technique as well. His meetings with Chang Yu-sheng and Li Tsai gave him the opportunity to learn Ming techniques of coloring and the use of ink that had not been taught by Josetsu or Shūbun. Sesshū's recognized stature as a major painter ensured that these new ideas and techniques quickly influenced his contemporaries. His visit to Ming China was thus far more than simply a personal journey.

Sesshū the Painter

Sesshū's stature as a painter is seen most clearly by comparison with his mentor Shūbun. Where Shū-bun's work tends to be idealized, abstract, and poetic, Sesshū's is down to earth and informed by direct ob-servation of nature and everyday life. Where Shūbun's landscapes are uniform in subject matter and tone,

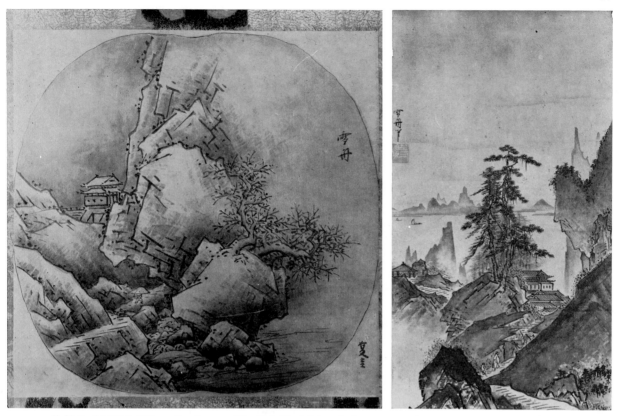

75. (left) Sesshū Tōyō: Winter Landscape. After Hsia Kuei. Ink and colors on paper; ht 33.5, w 31.5 cm. Late 15th century. Asano Collection, Tokyo.
76. (right) Sesshū Tōyō: Landscape. Detail. Inscriptions by Bokushō Shūshō and Ryōan Keigo. Ink and colors on paper; ht 118, w 35.5 cm. National Treasure. Early 16th century. Ohara Collection, Okayama.

those of Sesshū (Plates 72, 74, 76, 79) are rich and varied in scene and make free use of both ink and color. Where Shūbun's works, like those of Josetsu, are unsigned, the painter's identity obscure and the style self-effacing, Sesshū's paintings assert his awareness of his individuality, self-consciousness, and potential as an artist. They are not only boldly signed "Sesshū" or "Sesshū of the First Seat at T'ien-t'ung in Ssuming," but also frequently bear his age as well.

Hui-k'o Showing His Severed Arm to Bodhidharma (Plate 81), for example, is one of the finest of Sesshū's hanging scrolls. The vibrant, powerfully painted rock face, the strong lines of Bodhidharma's robe, and the determined profiles of the master and his would-be disciple emphasize the gravity of this crucial encounter. The row of characters to the left of the painting

states: "This was painted by Sesshū, holder of the First Seat at T'ien-t'ung, Ssuming, age seventy-seven." According to Zen tradition, Hui-k'o, anxious to learn Zen teachings, approached Bodhidharma, who was sitting in extended meditation facing a wall at a temple. Bodhidharma is said to have ignored Hui-k'o's entreaties to accept him as a follower until the latter, as a sign of his utter determination, cut off an arm.

Nearly fifty when he returned from China, Sesshū did not go back to Kyoto. He spent some time in Yamaguchi, the castle town of the Ouchi warrior family, but by 1476 he had moved and built himself a studio called the Tenkai Togarō in the coastal town of Oita on the Inland Sea coast of Kyūshū. In 1481 he stayed for a while at the Shōhō-ji temple in Mino;

審曳兒孫不知禪
眼空四海誰說訝
三十六年来肩上重
一人荷擔松源禪
前住大德一庥和尚
頂相自賛謹謹拝書

77. (opposite) Bokusai: Ikkyū. Ink and colors on paper; ht 43.6, w 26.3 cm. One of the masterpieces of Japanese portraiture, this portrayal of the sharp-tongued, irreverent monk Ikkyū (1394–1481) was painted by Bokusai Shōtō, the monk who succeeded Ikkyū as abbot of the small Zen temple of Shūon-an in Tanabe, between Kyoto and Nara. Because Bokusai, himself a talented ink painter, was undoubtedly familiar with the work done at Daitoku-ji, it was perhaps through Shūon-an that the influence of the Daitoku-ji painters spread to those in Nara. c. 1480. Tokyo National Museum.

78. Lan-ch'i Tao-lung. Artist unknown. Inscription by Lan-ch'i. Ink and colors on silk; ht 105, w 46.4 cm. National Treasure. This chinzō —the name given to portraits of renowned Zen monks—is done with a sharp realism that marks Southern Sung portrait painting styles. The thin, flowing black lines and the somewhat subdued colors are also indications of Chinese influence, for these are characteristics not heretofore seen in Japanese portrait painting. The Chinese Zen high priest Lan-ch'i (1213–78; known in Japan as Rankei Dōryū) came to Japan in 1246 at the invitation of a Kyoto monk who had studied in China. He was one of the several Chinese monks who introduced Sung-style Zen practices at new temples such as Kenchō-ji, which were built especially for these eminent Chinese monks. This portrait is dated 1271, and the donor is thought to be Hōjō Tokimune (1251–84), son of the Hōjō regent whose favor Lan-ch'i had enjoyed. 1271. Kenchō-ji, Kamakura.

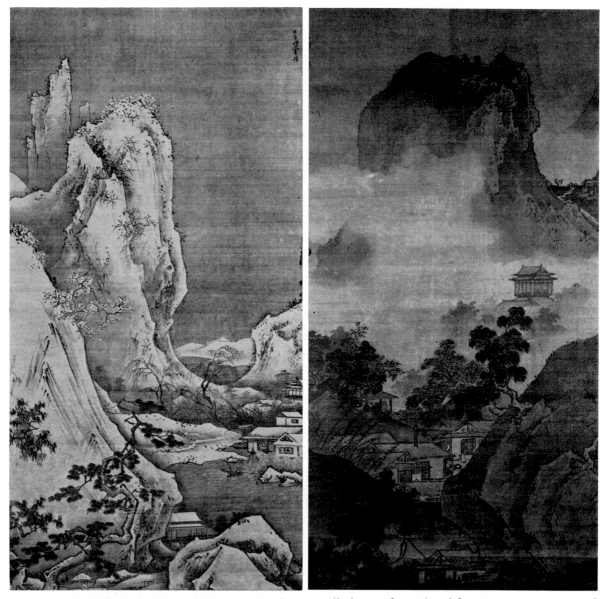

79. *Sesshū Tōyō:* Landscapes of the Four Seasons. *Four hanging scrolls showing, from right to left, spring, summer, autumn, and winter. Ink and colors on silk; ht 149.3, w 75.9 cm each. c. 1468. Tokyo National Museum.*

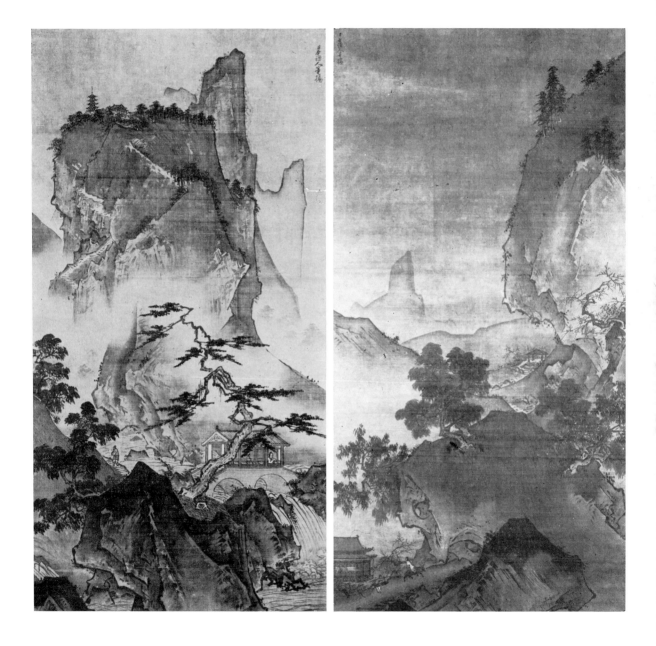

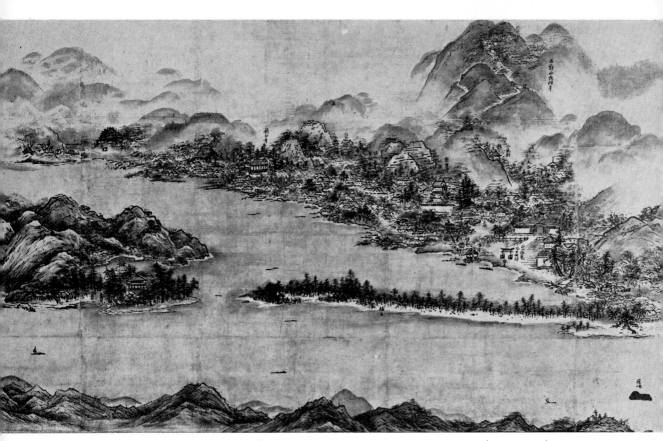

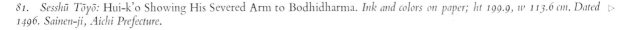

80. Sesshū Tōyō: Ama no Hashidate. Detail. Ink and colors on paper; ht 89.4, w 168.5 cm. National Treasure. About 1503. Kyoto National Museum.

81. Sesshū Tōyō: Hui-k'o Showing His Severed Arm to Bodhidharma. Ink and colors on paper; ht 199.9, w 113.6 cm. Dated ▷ 1496. Sainen-ji, Aichi Prefecture.

from there he moved to Iwami, and in 1486 returned to Suō, where he again established a studio called the Tenkai Togarō in the old Unkoku-an building. In his travels from Japan to China and throughout Japan Sesshū the Zen monk was living the early Zen ideal— moving from place to place in quest of direct experience and enlightenment. For Sesshū the painter, the new scenes, people, and customs provided valuable raw material.

By the time he returned to Suō in 1486, however, Sesshū, who was nearing seventy, may have felt that it was time to settle down. He spent most of the last twenty years of his life in Suō, and it was during this period that he produced his masterpiece, the long scroll *Landscape of the Four Seasons* (Plates 73 and 82). He must have made at least one more journey, for

the descriptive painting of the famous beauty spot of *Ama no Hashidate* (Plate 80) painted in his early eighties, is obviously based on close and detailed observation of the place. The date of Sesshū's death is unclear. He certainly lived to the age of eighty-three and may have lived until 1506, when he would have been eighty-seven.

Considering the length of Sesshū's life, his mobility, his self-confidence as an artist, and his reputation in his own day, it is not surprising that many painters should have met and studied with him. Some of these contacts can be documented. Tōetsu was given a landscape scroll painted by Sesshū (in 1474). In the postscript to the scroll Sesshū urged him to study the work of the Chinese master Kao K'o-kung. Tōhon and Shūgetsu (see Plate 83) both accompanied Ses-

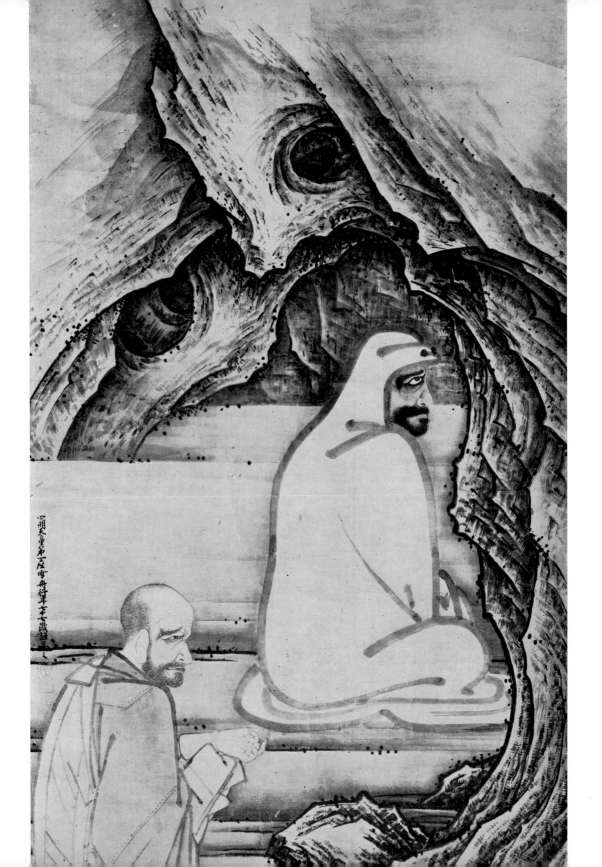

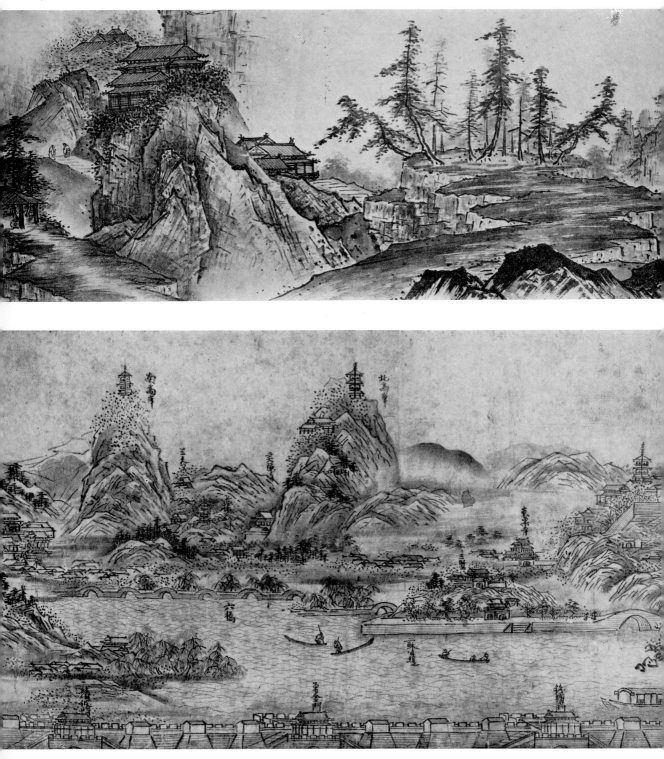

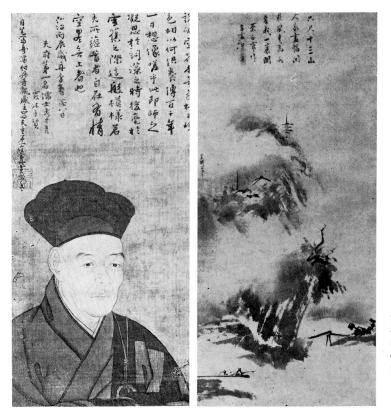

84. *(left) Sesshū:* Self-portrait. *Copy. Fujita Art Museum, Osaka.*
85. *(right) Sōen:* Haboku Landscape. *Ink on paper. Late 15th or early 16th century. Andō Collection, Tokyo.*

◁ 82. *(above) Sesshū Tōyō:* Landscape of the Four Seasons *(Long Landscape Scroll). Detail. Ink and colors on paper; ht 40, w 1807.5 cm. Dated 1486. Mōri Foundation, Bōfu, Yamaguchi Prefecture.*
◁ 83. *Shūgetsu:* The Western Lake (Hsi-hu). *Detail. Ink on paper; ht 46.6, w 84.8 cm. Late 15th century. Ishikawa Prefectural Art Museum, Kanazawa.*

86. *(below) Section of a letter by Sesshū addressed to Sōen. Umezawa Collection, Tokyo.*

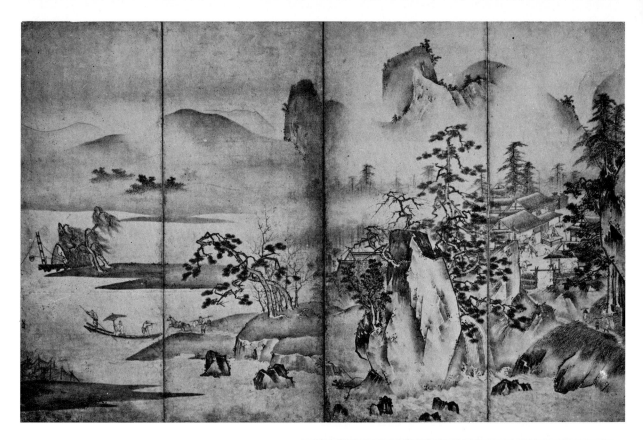

87. (above) *Yōgetsu:* Landscape. Folding screen. Ink
on paper. Late 15th or early 16th century. Umezawa
Collection, Tokyo.

88. *Sōen:* Landscape. *Ink on paper; ht 22.5, w 25 cm.*
Late 15th or early 16th century.

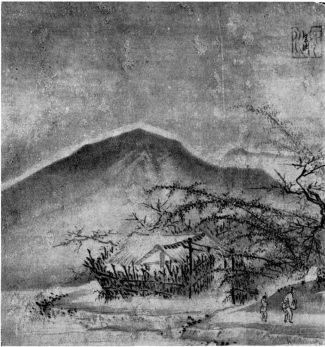

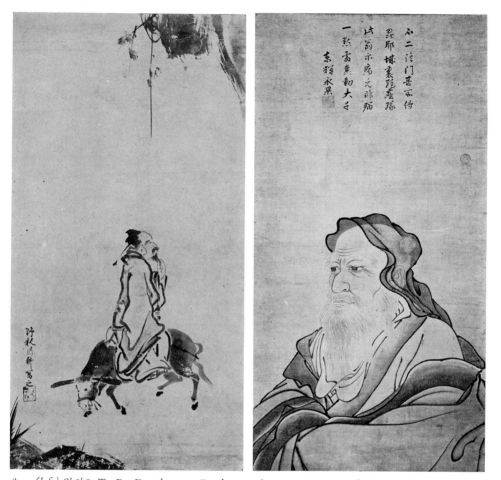

89. *(left) Shūkō: Tu Fu, Drunk, on a Donkey. 16th century. Museum of Fine Arts, Boston.*
90. *(right) Tōshun: Layman Vimalakīrti (Yuima Koji). Inscription by the monk Tōki Eikō. Ink and colors on paper; ht 115.5, w 55.4 cm. Early 16th century. Umezawa Collection, Tokyo.*

shū to China, and Shūgetsu was later given a self-portrait by Sesshū (Plate 84). Sōen, a Zen monk-painter from Engaku-ji in Kamakura, was given the *Haboku Landscape* (Plates 57, 70) as a farewell gift. Although Sesshū's influence is very much evident in Sōen's work (Plates 85, 88), his *Haboku Landscape* (Plate 85) is much less tense than that of Sesshū and makes more use of descriptive detail. Tōzen and Tōshun (Plate 90) are linked with Sesshū by their use of the character *tō* for Tōyō. The "gift" of a character from the master's name was common in Zen monasteries, and the character *tō* of Tōyō was traditionally much used in Shōkoku-ji, especially by monks belonging to the line of Zen founded by Mu-sō Soseki. Yōgetsu and Shūkō (Plates 87, 89), on

the basis of their style and from an entry in the *Honchō Gashi* (History of Japanese Painting) compiled in the Edo period (1603–1868), are also assumed to have studied with Sesshū. After Sesshū's death, Shūtoku carried on his work by maintaining the studio in the Unkoku-an. Apart from these painters for whom definite links with Sesshū can be established, there must have been many more who studied with him, met him on his travels, and admired his work. Although each of his students took something from Sesshū, none came near to rivaling him.

Sesson, the most brilliant of Sesshū's disciples, never met the master. He lived in the far north of Japan and was active as a painter only after Sesshū's death. However, he used the character "snow" from Sesshū's

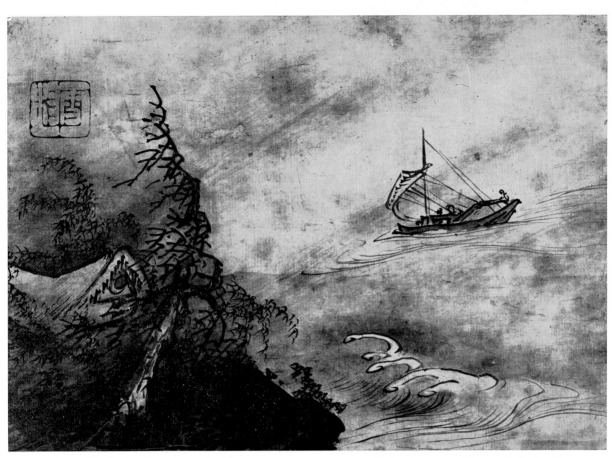

91. *Sesson:* Wind and Waves. *Ink and colors on paper; ht 22.4, w 31.4 cm. Early 16th century. Nomura Collection, Kyoto.*

name and clearly studied Sesshū's style. But Sesson was not a mere imitator. He had grasped the import of Sesshū's message that direct personal experience is essential, and his works reveal the imprint of an individual and powerful personality. Although the influence of Sesshū is apparent, the small painting shown in Plate 91 is characteristic of Sesson in its vigorous, confident brushwork and in the vivid impression it conveys of the inhospitable winter seas and stormy coastline of northern Japan.

5

The Daitoku-ji and Ami Painters

Sesshū was the last of a triad of great ink painters associated with Shōkoku-ji. Just as the center of ink-painting activity had earlier shifted from Tōfuku-ji to Shōkoku-ji, so after the Onin wars the focus shifted again to Daitoku-ji and the group of painters called upon to paint folding and sliding screens and scrolls for this monastery and its wealthy subtemples.

The Daitoku-ji Group

Although Daitoku-ji is a Rinzai monastery, its history is a complete contrast to that of the other Rinzai monasteries in the *gozan* system. Its founder, the monk Shūhō Myōchō (Daitō Kokushi, 1282–1337), was patronized by the retired emperor Hanazono and by Emperor Godaigo and served as Zen mentor to both. The monastery's relations with the Ashikaga, however, were less cordial. Whereas Daitoku-ji had been the foremost Kyoto *gozan* monastery under Godaigo, after his expulsion from Kyoto by Takauji in 1336 and the establishment of Ashikaga rule, it was demoted in favor of monasteries like Tenryū-ji and Shōkoku-ji, which had close ties with the monk Musō Soseki, the principal Zen confidant and adviser to the early Ashikaga shoguns.

By the end of the fourteenth century, Daitoku-ji was requesting permission to withdraw from the *gozan* system on the grounds that, in obedience to an injunction by Godaigo, it wished its abbacy to remain restricted to monks of the Daitō line of Zen. Monasteries in the official *gozan* system were expected to select their abbots irrespective of Zen affiliation.

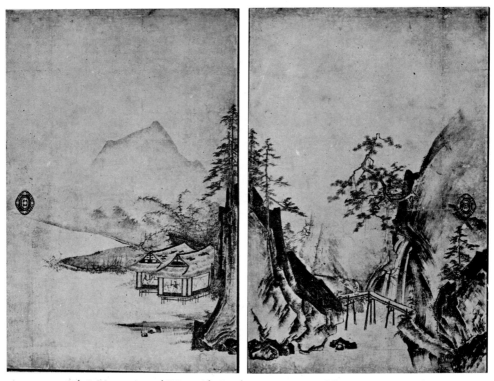

92. *Sōkei:* Mountain and Waterside Landscapes. *Two-panel* fusuma *painting. Ink and colors on paper; ht 169.2, w 115.8 cm each. Dated 1490. Kyoto National Museum (formerly in the Yōtoku-in, Daitoku-ji, Kyoto).*

93. Pumpkins and Mantis. *Attributed to Oguri Sōtan. Late 15th century. Yōmei Bunko Collection,* ▷ *Kyoto.*

Daitoku-ji secured its independence in the early fifteenth century and for the next fifty years preserved a dignified, possibly disgruntled, aristocratic independence. After the Onin wars weakened the *bakufu* and its *gozan* satellites, Daitoku-ji's fortunes took a turn for the better.

Two new wellsprings of strength for Daitoku-ji were the forging of ties with the merchant community of the port city of Sakai and the electrifying stimulus of the sharp-tongued, irreverent monk Ikkyū (1394–1481). Sakai merchants, growing rich on the profits of trade with China, Korea, and the Ryūkyū Islands, were eager to enjoy such upper-class cultural pursuits as the tea ceremony and its attendant arts. In the tea ceremony they found a common bond with Daitoku-ji monks. Ikkyū, forty-eighth in suc-

cession to Daitō, became abbot of Daitoku-ji in 1474. Already well known in Sakai, he played an important role in helping to promote the patronage of Daitoku-ji by its citizens. But despite the economic success, his term of office must have been a stormy one. Daitoku-ji Zen had hitherto been aristocratic in tone, molded in the Sung tradition and by the monastery's ties with the Japanese imperial line. Ikkyū introduced a more boisterous, earthy streak. In forthright, often vulgar language he scoffed at the hypocrisy of monks who entered Zen monasteries for a secure and easy life, lashed out at the hierarchical pomp and formalism of the *gozan,* and expounded, with the help of homely anecdotes, a practical Zen that townsman and villager could grasp and practice. Stimulated by Ikkyū and sustained by mercantile

patronage, the Daitoku-ji line, and its offshoot the Myōshin-ji line, began to win many adherents in the provinces.

In view of Daitoku-ji's independent tradition and its new-found wealth and vitality, it is hardly surprising that it should have become the center for a circle of ink painters. Unlike the earlier Tōfuku-ji and Shō-koku-ji painters, however, those associated with Dai-toku-ji were not necessarily monks trained in that monastery. By this time ink painting was no longer the exclusive preserve of Zen monks. Painters known to have worked for Daitoku-ji include the Oguri line of Sōtan, Sōkei, and Sōritsu; the gifted painter Bunsei; and members of the Soga circle—Soga Jasoku, Bokkei, Soga Shōsen, Soga Sōyo, Nara Hōgen Kantei, Bokusai Shōtō, Soga Chokuan, and Soga Shōhaku.

· OGURI SŌTAN. When Oguri Sōtan (d. 1481) suc-ceeded Shūbun as official painter to the *bakufu* around 1463, he was in his fifties. Nothing that can be posi-tively identified as his work exists today, but a wealth of references in documents of the 1460s and 1470s to *fusuma* paintings done by Sōtan in temples or in the villas of court nobles and warriors leaves no doubt that in his day he was a major painter. In 1489 Sōtan's son Sōkei completed a series of *fusuma-e* thought to have been started by his father in the Yōtoku-in, a subtemple of Daitoku-ji (one pair, Plate 92). These paintings have survived and provide some clues to Sōtan's style. In contrast to Shūbun's "vertical" land-scapes, Sōtan and his son seem to have preferred broad, expansive compositions, although this preference may have been dictated by the fact that they were painting

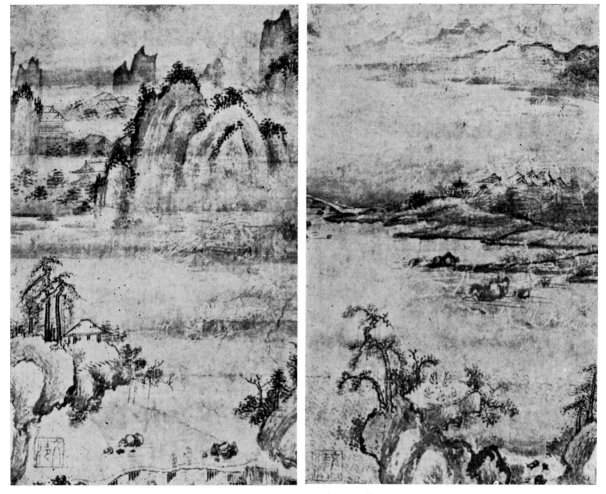

94. *Bunsei:* Landscape in the Korean Manner. *Mid-15th century. Takano Collection.*

95. *(left)* Lotus and Heron. *Bearing a seal reading Geiai.* ▷
Early 16th century.
96. *(center) Bunsei:* Layman Vimalakirti *(Yuima Koji). In-* ▷
scription by Sonkō Sōmoku. Ink on paper; ht 92.7, w 34.4 cm.
Dated 1457. Yamato Bunkakan, Nara.
97. *(right) Bunsei:* An Ox Grazing. *Inscription by Ryōan* ▷
Sōgen. Mid-15th century.

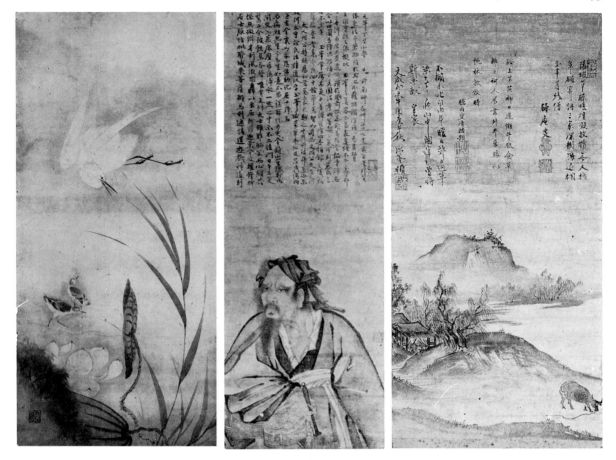

the lateral expanse of sliding-door panels. The Yō-toku-in paintings show considerable influence of the style of the Southern Sung master Mu Ch'i. Sōtan is said to have taken a character from Mu Ch'i's name to make a personal name for himself, and wild geese that resemble those of Mu Ch'i's works are prominent in the Yōtoku-in *fusuma* paintings. In addition to land-scapes, a number of bird and flower paintings done in color are ascribed to Sōtan (Plate 93), but, as with the landscapes, it is impossible to be certain that these are in fact his. That many such works are attributed to him does suggest, however, that he was accom-plished in this genre as well.

A painter who also seems to have belonged to the Oguri circle is Sōritsu, active in the early sixteenth century. He frequently used as his seal the two-char-acter compound Geiai, meaning "lover of the arts." Appropriately, this seal appears both on landscapes and colored bird and flower paintings (Plate 95). Despite the fact that they did not paint exclusively for Daitoku-ji, all the Oguri painters had ties with that monastery. Sōkei's *fusuma-e* still belong to the Yōtoku-in, and the person who asked Sōtan to paint them was the Daitoku-ji Zen master Shumbō Sōki. In addition, a number of Sōritsu's paintings bear inscriptions by Daitoku-ji monks.

• BUNSEI. Bunsei, a brilliant contemporary of Sōtan's about whom all too little is known, was also commis-sioned by Daitoku-ji. He is known to have painted a portrait of the Daitoku-ji abbot Yōsō in 1452 and may have practiced Zen under his guidance. Bunsei's mas-

98. Landscapes with Flowers and Birds. *Attributed to Jasoku. Six* fusuma *panels. Important Cultural Property. Late 15th century. Shinju-an, Daitoku-ji, Kyoto.*

terpiece is unquestionably the arresting study of the Buddhist layman Vimalakīrti (Plate 96). Although he was obviously a master of portraiture, Bunsei was also an accomplished landscape painter. *An Ox Grazing* (Plate 97), with an inscription by the monk Ryōan Sōgen, bears a seal reading Bunsei. Although the character *sei* is not the one normally used by Bunsei, the fact that Ryōan Sōgen was a Daitoku-ji monk suggests that this painting may have been done by the man who painted the Vimalakīrti study. Other landscapes (see Plate 94) are more definitely by Bunsei. Bunsei's landscape style is characterized by delicate, clear-cut brushstrokes, a generally rather lateral composition, and by hints of Korean influence (Plate 94). Painted on Korean paper, possibly while Bunsei was in Korea, the two paintings shown in Plate 94 show traces of Korean influence in the style of the trees and mountains. They also establish a connection between Bunsei and the Daitoku-ji circle of painters. The Korean motif of the group of figures seated on a rock (right-hand painting) was also used by Ikkyū's disciple Bokusai Shōtō, who, through Ikkyū, had close connections with Daitoku-ji. Even if Bunsei never actually went to Korea, his work is certainly

well known there, and a painting with a seal resembling his survives today in a Korean collection.

• SOGA JASOKU. Soga Jasoku is a major figure among the Daitoku-ji painters, but unfortunately he is one of the most controversial figures in the history of Japanese *suibokuga*. Some scholars hold that he was the son of the Korean painter Yi Su-mun who is thought to have accompanied Shūbun on his return to Japan in 1424 and later worked for the Asakura family in Echizen (present-day Fukui Prefecture). In the Shinju-an, a subtemple of Daitoku-ji, there are *fusuma* paintings of landscapes with birds and flowers (see Plate 98) attributed to Jasoku, and in their forceful angular brushwork these do indeed have something in common with the brushwork of Yi Su-mun. The fact that Shūbun, Bunsei, and Jasoku all had links with Korea indicates the extent to which Japanese artists of the Muromachi period were aware of Korean ink painting. And the fact that Bunsei and Jasoku both painted for Daitoku-ji suggests that more research into the relations between the Daitoku-ji circle and contemporary Korean ink painters will further illuminate this phase of Japanese ink painting.

99. *(right)* Bodhidharma. *Attributed to Bokkei-Jasoku. Late 15th century. Shinju-an, Daitoku-ji, Kyoto.*

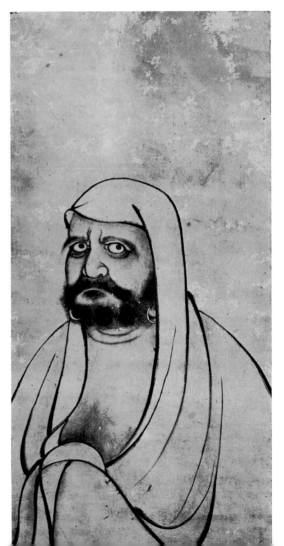

The historical Soga Jasoku is as hard to pin down as Josetsu's catfish. Documents belonging to the Shinju-an mention a Fusen Sōjō, also known as Jasoku, whose date of death is given as the 17th day of the 11th month. No year is mentioned. According to the *Honchō Gashi* (History of Japanese Painting) compiled by Kanō Einō in the Edo period, Jasoku was originally a warrior from Echizen who studied Zen under Ikkyū and painting with Shūbun and who painted a number of works for the Shinju-an. Other Edo-period sources state that Fusen Sōjō was actually the lay priest Soga Shikibu, a retainer of the Asakura family of Echizen, who adopted the title Jasokken and studied Zen under Ikkyū. Both accounts agree on the link with Ikkyū, and among works attributed to Jasoku, some—for instance, the *Buddha in Austerities* and the *Zen Master Lin-ch'i*—bear inscriptions by Ikkyū. However, neither these works nor the landscape *fusuma-e,* nor indeed any of the works attributed to Jasoku, bear the seal or signature Jasoku. There is no mention of the name Jasoku in contemporary sources; it first appears in later documents of the kind referred to above.

Although the link between Ikkyū and Jasoku can-

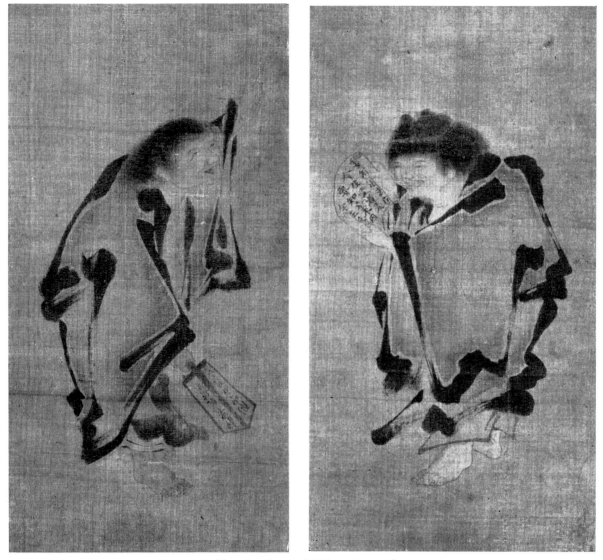

100. Bokkei: Han-shan and Shih-te. *Late 15th century.*

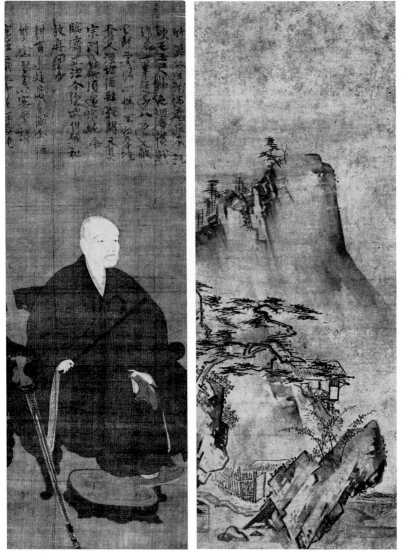

101. (left) Bokkei: Ikkyū. *Inscription by Ikkyū. Late 15th century. Umezawa Collection, Tokyo.*
102. (right) Landscape. *Bearing the seal Sekijō. Late 15th century. Sawada Collection.*

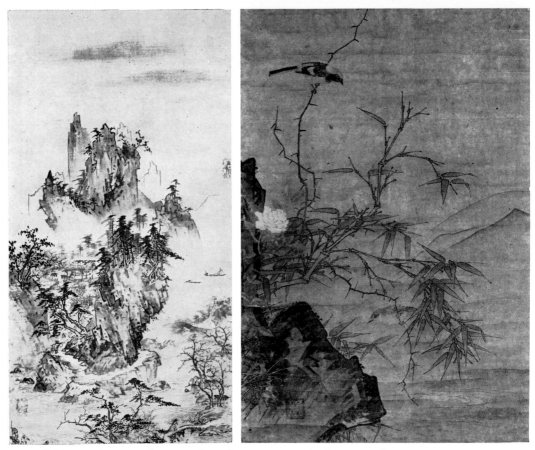

103. *(left) Soga Shōsen:* Landscape. *Early 16th century. Nezu Art Museum, Tokyo.*
104. *(right) Sōyo:* Flowers and Birds. *Late 15th or early 16th century.*

not be verified, the link between Ikkyū and a contemporary who signed himself Bokkei is clear, and there is evidence that Bokkei and Jasoku are one and the same man. There are a number of poems from the *Kyōunshū* (Mad Cloud Anthology) by Ikkyū that also appear as inscriptions on paintings attributed to Bokkei. In the *Biographical Chronology of Ikkyū* there is an entry for 1479 stating that Ikkyū added an inscription to a painting by Bokkei entitled *Looking at Peach Blossoms under Auspicious Clouds.* Bokkei is also mentioned in the writings of the Zen abbot Son'an as having studied painting with Shūbun and as having received from him a certificate of proficiency as a painter.

Among Bokkei's extant works are paintings of Bodhidharma (Plate 99) and Han-shan and Shih-te (Plate 100), and a portrait of Ikkyū bearing an inscription by Ikkyū (Plate 101). On the Han-shan Shih-te painting and the Ikkyū portrait, in addition to the seal reading Bokkei, there is a circular seal reading Saiyo. The name Saiyo, with the same two characters, is also recorded as having been used by Jasoku. There are records stating that a number of works bearing a seal reading Sekijō existed, that these were close in style to the landscape *fusuma-e* attributed to Jasoku in the Shinju-an, and that some of these works bore two seals, one reading Sekijō; the other, Saiyo. Taken together, these clues point to the conclusion that the painters Jasoku and Bokkei-Saiyo are one and the same and that this painter also used the name Sekijō.

105. Sōami: Landscapes. *Decorated* fusuma, *now mounted as hanging scrolls. Ink on paper; ht 174.8, w 140.2 cm each. Painted 1509. Daisen-in, Daitoku-ji, Kyoto.*

This conclusion, which is of course provisional, is supported by stylistic analysis of works attributed to Jasoku and those bearing the seals of Bokkei, Saiyo, and Sekijō (see Plate 102). The problem of explaining the relationship of Jasoku to Fusen Sōjō remains, but at the moment it seems wisest to treat all the above-mentioned works as the product of a single painter whom, for convenience, we shall refer to as Jasoku. As shown in these works, his style is characterized by highly individual brushwork aptly described by the *Honchō Gashi* as "having the power and fluid elegance of cursive calligraphy." At the same time there is in it a wryness reminiscent of Daitoku-ji and Ikkyū Zen.

Jasoku was succeeded by Soga Shōsen, several of whose landscapes are extant (Plate 103). Compared with Jasoku's work, they are small in scale. Of similar stature as a painter was Sōyo, who specialized in bird and flower painting (Plate 104). The Jasoku style was preserved most vitally in the work of Nara Hōgen Kantei, a Nara monk. Some of the landscapes attributed to Kantei (Plates 106, 109) could easily be mistaken for the work of Jasoku. Since his bird and flower paintings (Plate 107) show traces of the Sōtan style, it is clear that Kantei was also influenced by the Daitoku-ji Oguri circle.

The small Zen temple of Shūon-an in Tanabe, between Kyoto and Nara, was founded for Ikkyū. The monk who succeeded Ikkyū as abbot, Bokusai Shōtō, was a talented ink painter whose portrait of Ikkyū

106. Kantei: Autumn and Winter Land-scapes. One of two panels. Late 15th century. Kusaba Collection, Tokyo.

(Plate 77) is one of the masterpieces of Japanese portraiture. Since the Shūon-an was not far from Nara, it is possible that with this temple as a kind of stepping stone, Daitoku-ji painters influenced Nara painters.

Later bearers of the Soga name were Soga Chokuan in the later sixteenth century and Soga Shōhaku in the Edo period. Both were influential painters in their day, and although there was no direct family connection between these two painters and Jasoku, through them the Jasoku style linked with Ikkyū's Zen continued to influence Japanese ink painting.

The Ami Group

The name Ami, which is so prominent in the cultural history of the Muromachi period, was derived from Amida (in Sanskrit, Amitābha), the name of the Buddha of the Pure Land or Paradise of the West. The Ami name was adopted as a profession of faith by many of those who believed in the efficacy of constant repetition of the name of Amitābha (the *nembutsu*), especially by members of the Ji (Timely) sect founded by Ippen Shōnin (1239–89). This sect spread widely among the common people and counted among its members many artisans, craftsmen, and artists. Some of the most celebrated bearers of the Ami name—Nōami, Geiami, Sōami, Daiami, Kan'ami, Zeami, and Zen'ami—were adherents of the Ji sect. In the priestly robes of Ippen's disciples, they served the Ashikaga shoguns as personal attendants or *dōbō-*

107. *Kantei:* Peonies and Butterfly, Cherry Blossoms and Sparrow. *Late 15th century.*

shū, acting as masters of the tea ceremony or flower arrangement, as garden designers, interior decorators, painters, poets, musicians, and writers and performers of Nō and Kyōgen, as well as confidants and cultural advisers.

The Ami ink-painting school had at its core three generations of such *dōbōshū.* Nōami (c. 1394–1471) was a contemporary of Shūbun's and had the family name of Nakao before adopting the Ami title. He was an extremely talented man, active as ink painter, mounter of scrolls, decorator, linked-verse poet, and connoisseur of things Chinese. The Ami line was continued by his son Geiami (1431–85) and his grandson Sōami (d. 1525). The three Ami were principally responsible for appraising and cataloging Chinese

paintings as well as producing original *suibokuga.* As classifiers, they compiled two of the most important Muromachi-period catalogs of imported Sung- and Yüan-period paintings in the shogunal collection from the time of Yoshimitsu: the *Gyomotsu On'e Mokuroku,* compiled by Nōami, and the *Kundaikan Sōchōki,* compiled by Sōami.

In the *Gyomotsu On'e Mokuroku,* Nōami classified imported paintings by painter, size of work, whether painted on paper or silk, and whether painted as a single scroll or part of a set. Some of the ninety or so items listed are still in existence—for instance, the *Eight Views of the Hsiao-Hsiang* by Mu Ch'i (Plate 22) and *Peach Tree and Dove* by Emperor Hui Tsung (Plate 38). The *Kundaikan Sōchōki* differs from the

108. Pine Strand of Miho. *Attributed to Nōami. Hanging scrolls, originally one of a pair of folding screens. Ink on paper; ht 155.3, w 55.1 cm (scrolls 1, 6), w 59.2 cm (scrolls 2, 3, 4, 5). Mid-15th century. Egawa Museum of Art, Hyōgo Prefecture.*

Gyomotsu On'e Mokuroku in that it also provides thumbnail biographies of the painters included and ranks them into three categories, each further divided into three grades. It also describes the most suitable interior setting for the proper display and enjoyment of Chinese paintings and works of art and thus must have served as a valuable guide to their understanding and enjoyment.

In establishing a vertical order of merit, Sōami was departing from Chinese practice, which had generally been to categorize painters not so much in hierarchical order as in terms of the particular excellence of their style—whether "divine," "sublime," "mysterious," or "untrammeled." In making this ninefold classification the compiler, influenced by his religious back-

ground, probably had in mind the nine levels of the Western Paradise as described in Pure Land scriptures. Pure Land numerology may also have led him to put forty-eight Chinese painters in the top category. The number forty-eight describes both the forty-eight Pure Vows made by Amitābha on behalf of mankind and also the forty-eight auspicious Chinese characters prefacing the Ami title granted to someone of great excellence in the Ji sect. Whether or not Sōami was overtly emphasizing his religious beliefs, it is important to remember that in an age when Zen thought was dominant, adherents of other branches of Buddhism were also active in the arts and that members of the Ji sect in particular made a major contribution to Muromachi culture.

As connoisseurs and critics, the Ami were frequently requested by their shogunal patrons to find works in the style of Ma Yüan, Hsia Kuei, or Sun Chün-tse, and to give advice on the mounting and hanging of these paintings. They also selected Chinese stylistic models for Japanese painters and commented on the style and techniques of the Chinese masters. Contemporary documents include numerous quotations of such comments and critiques of Chinese painting by Sōami, and a number of existing hanging scrolls also mention titles he composed for Chinese paintings.

As painters, the three Ami, unlike painters of the other major *suiboku* schools, tended to rely on expression through surface effects rather than line; they defined objects not by outline drawing but by suggesting shape. Many of their paintings are pervaded by a misty quality reminiscent of the "boneless" *mo-ku* style originated by Wang Wei and developed by Mi Fei (Plate 1) and Li Lung-mien that became firmly established in the Northern Sung. Detail is kept to a minimum and forms are summarized with techniques called *tsao-ti (sōtai)* taken from the *tsao-sho (sōsho)*, the summary draft script of Chinese calligraphy and the most rapid and abbreviated writing form. This "boneless" style was probably originally inspired by the cloudy, rain-drenched mountains and mist-shrouded waters of southern China, particularly the magnificent scenery of the Hsiao and Hsiang rivers in the region around the Tung-t'ing lake. A popular theme, frequently painted in this veiled and misty manner by

109. Kantei: Mountain Landscape. *Late 15th century. Tokyo National Museum.*

Chinese artists, was that of the eight famous views of Hsiao-Hsiang as designated by the Southern Sung man of letters Sung Shih.

Paintings of these eight views by Mu Ch'i (Plate 22), Yü Chien (Plate 24) and other Chinese painters were brought to Japan during the Muromachi period and used as models by Japanese painters. Both Nōami and Sōami painted several versions of the eight views, possibly partly because the variety of scenery, season, and time of day provided practice in a wide range of landscape techniques and effects. The misty quality of Ami painting as derived from the ethereal mood of Chinese paintings of the eight views is evident in the *byōbu* painting called *Pine Strand of Miho* (Plate 108) attributed to Nōami, and in the *fusu-*

ma-e from the abbot's quarters at Daisen-in (Plate 105) attributed to Soami.

Although the "boneless" style is most characteristic of the Ami, they did not reject other styles completely. In *White-robed Kannon* (Plate 111), painted in 1468 by Nōami for his son Shūken; in Geiami's painting of the poet Li Po gazing at a waterfall (Plate 112), painted for the Kamakura Zen monk Kei Shoki; and in Sōami's *Gazing at a Waterfall* (Plate 113), use is made of the simple descriptive landscape style of *chen-t'i,* the name taken from the basic regular script *(chen-shu,* or *shin-sho)* in Chinese calligraphy. The fact that Nōami chose to paint in this style for his son and that Geiami used it in a painting for his student implies that the Ami considered this a basic style for landscapes.

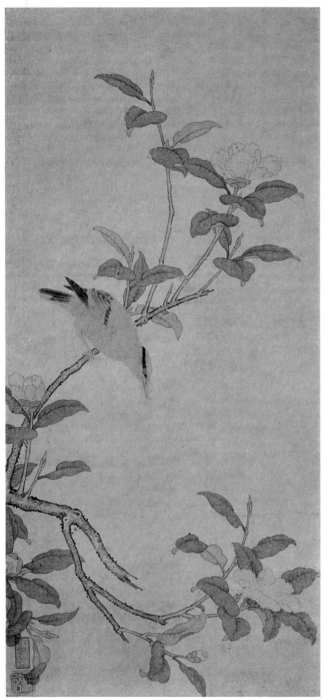

110. *Kei Shoki:* Birds and Flowers. *Ink and colors on paper; ht 82.2, w 32.7 cm. Kei's careful study of Chinese techniques through the opportunity he was given to examine and copy the paintings in the shogunal collection in Kyoto then under the care of his mentor, Geiami, is evident in this work, which in its delicate brushwork and clear color tones shows considerable refinement of the rougher style he had earlier learned from the Kamakura monk Chūan Shinkō. The most important of the Kamakura painters, Kei lived and worked at Kenchō-ji. 15th century. Kyoto National Museum.*

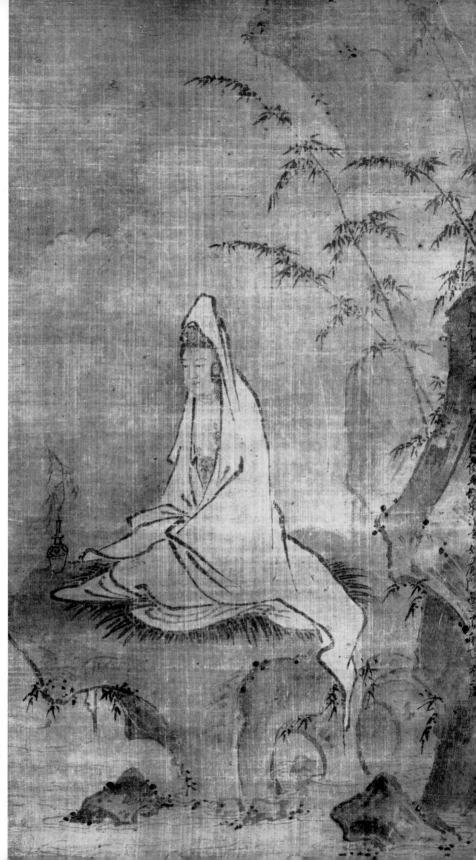

111. *Nōami:* White-robed Kan-
non. *Ink and colors on silk; ht
109, w 38.2 cm. Dated 1468. Pri-
vate collection.*

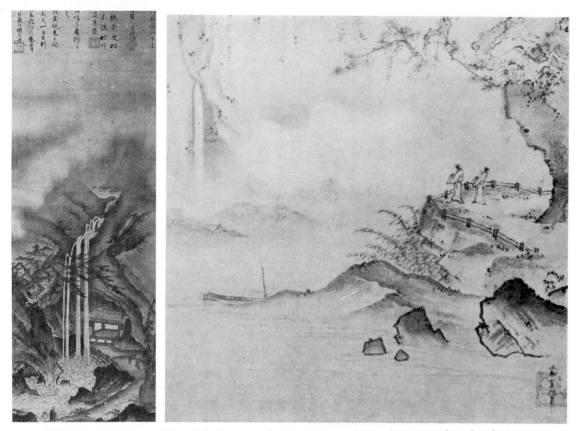

112. *(left) Geiami: Viewing a Waterfall. Inscriptions by Osen Keisan and two other Zen monks. Ink and colors on paper; ht 105.8, w 30.3 cm. Dated 1480. Nezu Art Museum, Tokyo.*
113. *(right) Sōami: Gazing at a Waterfall. Late 15th century.*

The Ami were unique among Muromachi-period painters as artisan-artists and *nembutsu* believers who were on intimate terms with the Ashikaga shoguns and had a detailed knowledge of Chinese art and culture. They popularized the "boneless" *mo-ku* style and contributed to the development and diversification of Muromachi-period *suibokuga*.

The core of the Ami school was the family line of Nōami, Geiami, and Sōami, but others belonged to this circle as well. The Kamakura Zen monk Kei Shoki, for instance, studied under Geiami and through him had access to the Chinese paintings in the shogunal collection. Stylistically, however, Kei Shoki's work differs so much from that of the Ami that he is better treated as a central figure of the Kamakura school, which will be discussed in the following chapter. The Ami style was most faithfully inherited by Tan'an Chiden from Amagasaki, the son of an artisan-painter who worked for the Hongan-ji, center of the New Pure Land sect founded by Shinran. Tan'an was typical of the Ami in that he was the son of an artisan and a *nembutsu* believer, and such works as his bird and flower study and *Distant Temple Bells in the Evening* are stylistically in the Ami tradition.

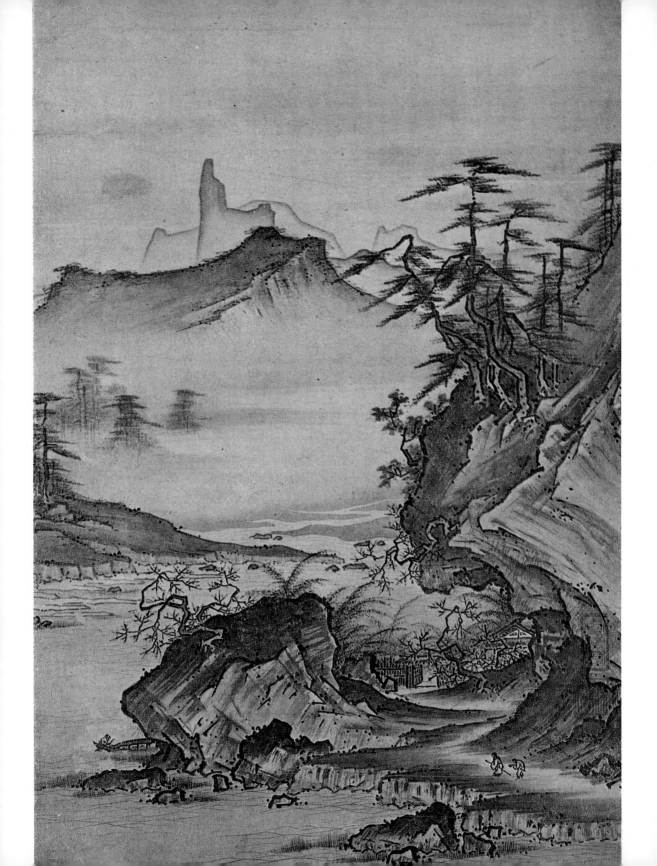

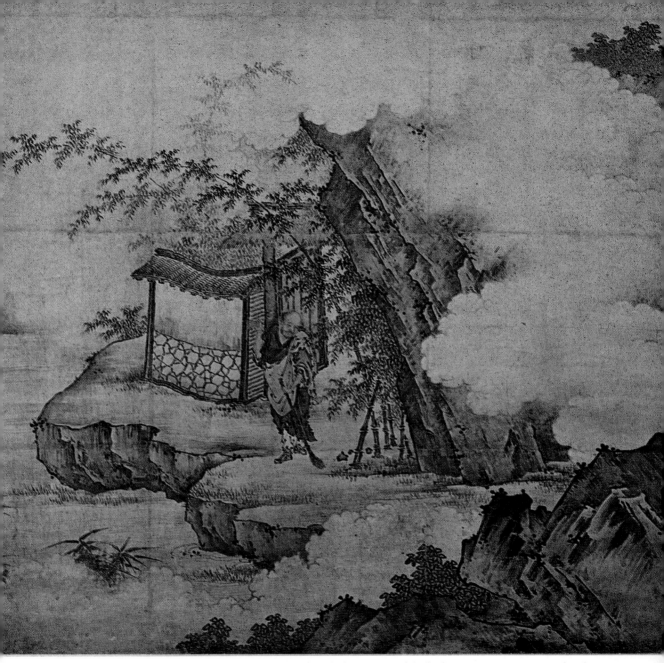

115. *Kanō Motonobu:* Zen Master Hsiang-yen Attaining Enlightenment. *Ink and colors on paper. Important Cultural Property.* *Originally painted on fusuma in the abbot's quarters (hōjō) of Daisen-in, a subtemple of Daitoku-ji in Kyoto, this work was later mounted as a hanging scroll. It belongs to the category generally described as zenkizu, or didactic Zen paintings, and shows the T'ang-dynasty Zen master Hsiang-yen in the instant of his enlightenment as he hears his broom strike a stone. The painting was done when Motonobu (1476–1559) was about thirty-four years old. c. 1509. Tokyo National Museum.*

◁ 114. *Kei Shoki:* Landscape with Figures. *Light color and ink on paper; ht 51, w 33 cm. Important Cultural Property. This painting is characteristic of the Kamakura Zen monk-painter Shōkei or, as he is commonly known, Kei Shoki. While under the tutelage of the painter Geiami in Kyoto, Shōkei was able to make careful study of the Sung and Yüan paintings in the shogunal collection. Awareness of the angular landscape style of Ma Yüan and Hsia Kuei is apparent in the painting of mountain, rocks, and trees in this carefully constructed work. Late 15th century. Nezu Art Museum, Tokyo.*

6

The Kamakura Tradition

Although Kyoto with its great Zen monasteries and *bakufu* and court patrons remained the hub of ink-painting activity throughout the Muromachi period, it was by no means the only center. A *suiboku* tradition at least as old as that of Kyoto was nurtured in Kamakura, and by the middle of the Muromachi period, ink-painting groups were emerging in many smaller provincial centers as well. Ink painting probably began in Kamakura with the arrival of Zen, and was fostered initially in the monasteries of Kenchō-ji and Engaku-ji, the first full-fledged Chinese-style Zen monasteries in Japan. They were built in the years between 1250 and 1280 by the Hōjō regents for émigré Chinese Zen monks like Lan-ch'i Tao-lung (Rankei Dōryū), Wu-hsüeh Tsu-yüan (Mugaku Sogen), and Ta-hsiu Cheng-nien (Daikyū Shōnen).

Chinese Models

That painters who had mastered ink-painting techniques were active in Kamakura well before the end of the thirteenth century is indicated by the self-inscribed formal portrait or *chinzō* of Lan-ch'i (Plate 78), which clearly displays a use of ink-painting techniques hitherto unknown in studies of this kind, and by the *suiboku*-influenced studies of the Sixth Patriarch (Plate 21) and of the Chinese Poet Po Chü-i (772–846), both bearing inscriptions by Mugaku Sogen.

Kamakura painters learned these techniques through careful study of imported paintings. The *Butsunichi-an Komotsu Mokuroku,* compiled in 1320, shows that by the mid-fourteenth century this one subtemple of

116. Lu Hsin-chung: Arhat *(Rakan).*
13th century. Shōkoku-ji, Kyoto.

117. Hsi-chin Chü-shih: Arhat *(Rakan).*
13th century. Hara Collection, Tokyo.

Engaku-ji had in its possession several score of Chinese paintings accumulated from the time of its foundation in the thirteenth century. Thirty-nine of the paintings in the collection were *chinzō* of eminent Chinese Zen monks. The remaining thirty-six items included landscapes, bird and flower paintings, and works depicting Buddhist and Taoist motifs and figures *(dōshakuga).* Among the thirty-six were paintings of Pu-t'ai or the Zen patriarchs, with inscriptions by such famous Chinese Zen masters as Ta-hui Tsung-kao, Wu-hsüeh Tsu-yüan, Chung-feng Ming-pen, and Wu-an P'u-ning; avocational landscapes by Zen monk-painters; paintings of monkeys by Mu Ch'i, of dragons and tigers by Hui Tsung, and of birds and flowers in the four seasons by Li Ti.

Unfortunately, none of these survived the ravages

of war, fire, and natural disasters. They remained in existence long enough, however, to serve as models for artists in the earlier phase of Kamakura painting. Although it is difficult now to pinpoint that influence at work, two extant early Japanese works do seem to show Chinese influence and give some impression of the style of Kamakura Zen monk-painters of the late thirteenth and early fourteenth centuries. One such painting is *Wagtail and Withered Branch* (Plate 120), obviously inspired by Mu Ch'i, which bears an inscription by the monk Taikyo Genju, who spent some time in Kamakura. The other is a painting of Sākyamuni returning from the mountains (Plate 129) with an inscription by the Engaku-ji monk Tōmei Enichi.

Another likely source of instruction for Japanese painters were colored *rakan* (in Sanskrit, *arhat*) paint-

118. *Kanō Eitoku:* Plum, Bamboo, and Birds. *Detail. Ink over gold ground on paper; on four sliding screen panels* (fusuma); *ht 175.5, w 142.5 cm. National Treasure. According to the eighteenth-century* Honchō Gashi *(History of Japanese Painting) compiled by Kanō Einō, Eitoku usually worked on a massive scale, painting pine or plum trees with a spread of from six to seven meters and life-size human figures. This painting, part of a set of sixteen panels, is characteristic of his work in its scale and in the generous use of gold ink to create a brilliant effect. The rough texture of the ink-painted trees and rocks is probably the result of deliberate use of a well-worn brush. Momoyama period, late 16th century. Jukō-in, Daitoku-ji, Kyoto.*

ings of the kind possessed by both Kenchō-ji and Engaku-ji (Plates 116, 117). These were probably produced during the late Southern Sung or Yüan dynasties by professional Buddhist painters around Ssuming, the chief port city on the south-central Chinese coast. By contemporary Chinese standards these works would have been considered somewhat provincial and conservative, but they were novel and exciting to Japan. Japanese painters, in fact, were less interested in the *rakan* themselves than in the backgrounds, which frequently included elements of ink-painted landscape.

The influence of the ink-painted background scenes from these *rakan* paintings is evident in several works

—for instance, in the *Tōsei Eden,* a horizontal scroll belonging to the Tōshōdai-ji in Nara painted in Kamakura in 1298, which depicts the vicissitudes of the Chinese monk Chien Chen (Ganjin), founder of the Tōshōdai-ji, in his efforts to reach Japan. It is also seen in the scroll of the five Pure Land patriarchs *(Jōdo Goso Eden),* painted in 1305 and belonging to the Kōmyō-ji in Kamakura. Imported paintings on the theme of the Ten Kings of Hell, especially those by Lu Hsin-chung of Ssuming, which enjoyed a great vogue in the Kamakura period, frequently included miniature landscape vignettes decorating screens or walls within the large color paintings; these too provided grist for the mill of eager Japanese painters. That the influence of

119. *Chūan Shinkō:* Landscapes with Figures. *Mid-15th century. Kumita Collection, Tokyo.*

these landscape vignettes was not confined to Kamakura painters is evident from the fact that picture scrolls produced in Kyoto, such as the *Tengu Zōshi* (Stories of Conceited Priests), *Kasuga Gongen Reigen Ki* (The Kasuga Gongen Miracles), and the famous pictorial biography of Hōnen Shōnin in forty-eight scrolls, include within the largely *yamato-e*-style scenes depictions in miniature of ink-painted folding screens or *fusuma*. Moreover, the style of early Japanese ink painters like Shitan, Ryōsen, and Minchō was probably shaped by observation of such miniature ink landscape scenes appearing within larger color paintings.

For Kamakura Zen monasteries, the destruction of the power of the Hōjō regents in 1333 meant the loss of powerful and generous patrons. For Kamakura ink painters, it meant relative eclipse as the mainstream of cultural and political life swung suddenly in the direction of Kyoto. Kamakura itself, however, remained a great Zen center. Its monasteries survived intact, were accorded favors by the Ashikaga, and were eventually organized into a *gozan* hierarchy that enjoyed all the privileges of its Kyoto counterpart. This successful adjustment of the Kamakura Zen monasteries to changed political circumstances not only ensured the survival of Kamakura *suibokuga,* but also helped guarantee the subsequent development of ink painting in the Kantō region.

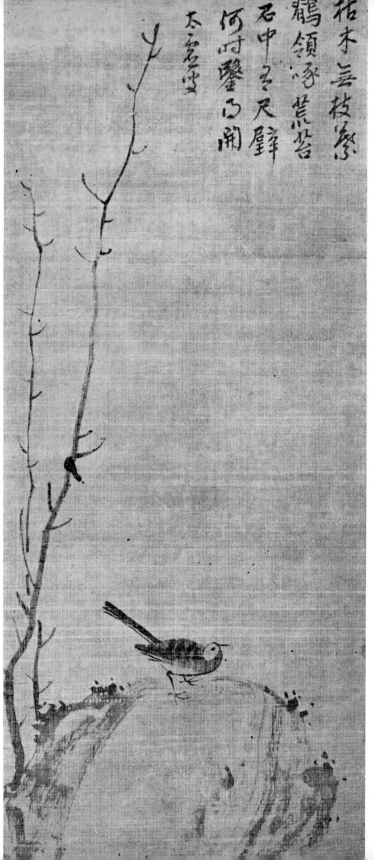

120. Wagtail and Withered Branch. *Artist
unknown. Inscription by Taikyo Genju. Painted
c. 1374. Yanagi Collection, Kyoto.*

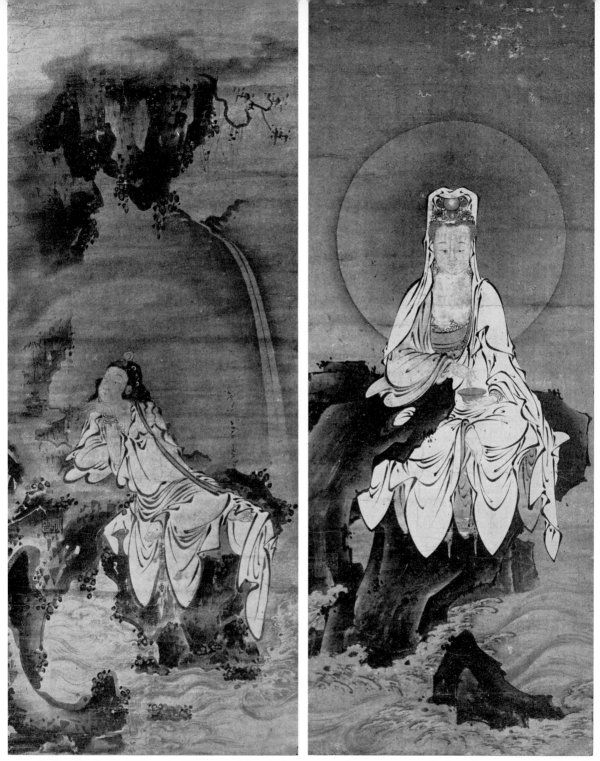

121. *(left) Sekkyakushi:* White-robed Kannon. *Ink and colors on paper; ht 93, w 34.5 cm. Early 15th century. Kobayashi Collection, Tokyo.*
122. *(right) Reisai:* White-robed Kannon. *Mid-15th century. Fujii Collection.*

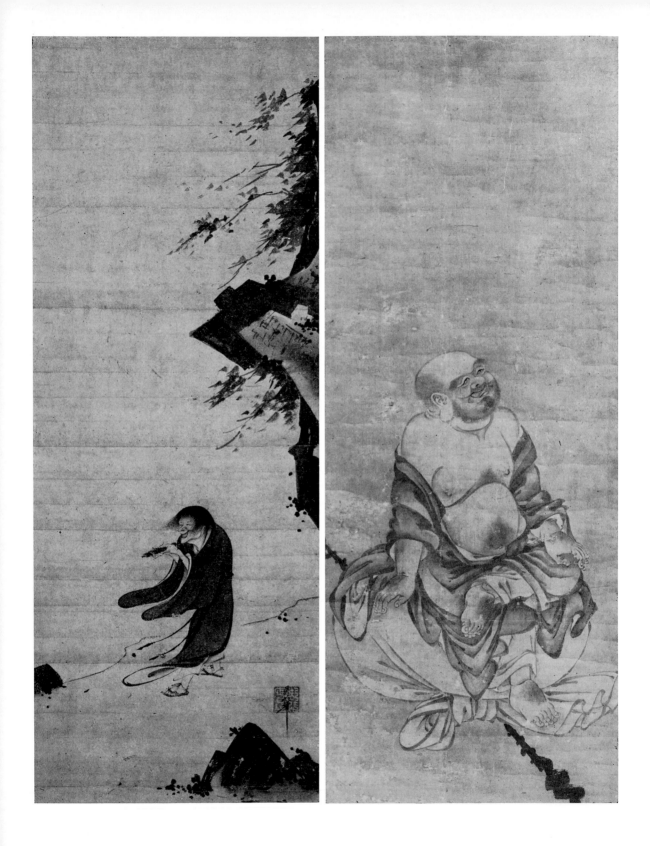

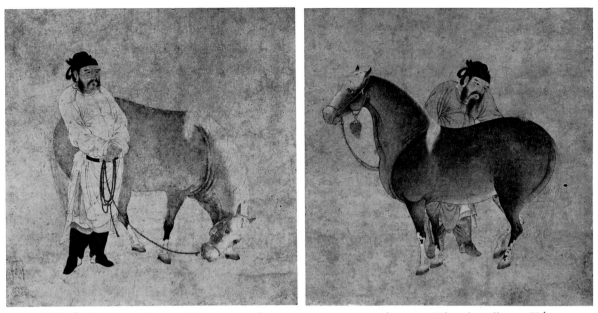

125. *Kei Shoki:* Horse and Groom. *Colors on paper; ht 38.5, w 39.5 cm. Late 15th century. Kobayashi Collection, Tokyo.*

◁ 123. *(far left) Reisai:* Han-shan. *Ink on paper; ht 83.9, w 35.5 cm. Mid-15th century. Daitōkyū Collection, Tokyo.*
◁ 124. *(near left) Chūan Shinkō:* Pu-tai. *Mid-15th century. Ario Collection.*

Kamakura Painters

The earliest Kamakura painters are hardly more than names to us. Gukei Jōkei, who was mentioned briefly above in the context of Josetsu and Minchō (Plate 41), is thought to have spent some time at the Kamakura monastery of Jufuku-ji. Links between Tōfuku-ji in Kyoto and the Kamakura Zen monasteries were particularly strong, and such Tōfuku-ji monk-painters as Isshi, Sekkyakushi (Plate 121), and Reisai (Plates 122 and 123) were all artists who influenced the style of the Kamakura school. *Sākyamuni Entering Nirvana* by Reisai, for instance, is in the collection of the Daizōkyo-ji, in Yamanashi Prefecture. In the work of Chūan Shinkō, a Kenchō-ji monk-painter (see Plates 119 and 124), and in the early

paintings of Kei Shoki who studied with him, it is possible to detect the unpretentious quality characteristic of the Tōfuku-ji circle, which also developed under the influence of the rustic, descriptive style of the painters of the Ssuming region. Chūan's way of painting trees in the background, for example, owes much to the style of professional Buddhist painters from Ssuming. Comparison of his works with those shown in Plates 116 and 117 shows how Kamakura painters trained themselves in ink techniques by careful study of Chinese paintings.

More is known about Kei Shoki, the most important Kamakura painter. Also known as Shōkei (his *imina*) and Kenkō (his *azana*), he held the office of secretary or *shoki* in Kenchō-ji and is usually referred to as Kei Shoki. After studying with Chūan Shinkō

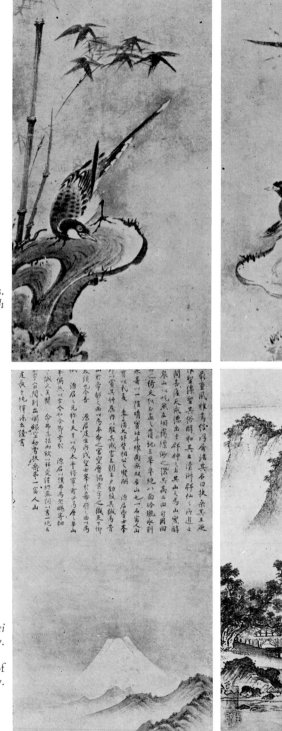

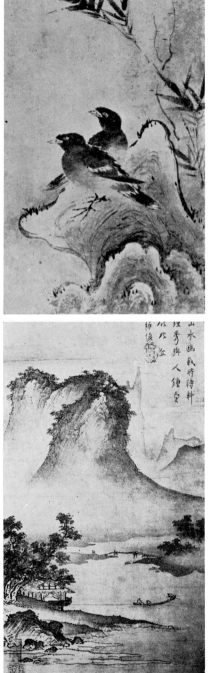

126. Keisessai: Birds on Rocks.
*Pair of hanging scrolls. Early 16th
century. Kusaba Collection, Tokyo.*

127. (left) Mt. Fuji. *Attributed to Kei
Shoki. Late 15th or early 16th century.
Tokyo National Museum.*
128. (right) Kei Shoki: Cottage of
the Evening Bell. *Early 16th century.
Ueno Collection, Hyōgo Prefecture.*

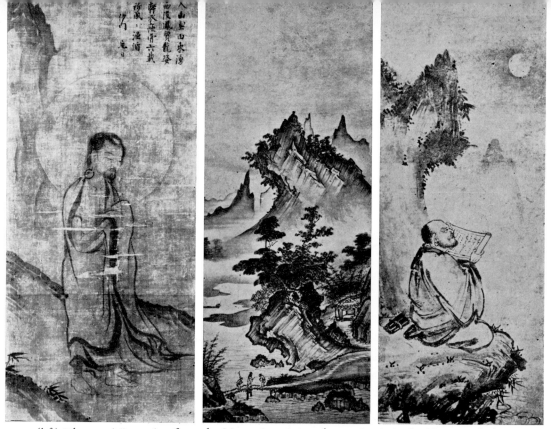

129. *(left)* Sākyamuni Returning from the Mountains. *Artist unknown. Inscription by Tōmei Enichi (Tung-ming Hui-jih, 1272–1340). Ink on silk; ht 72.4, w 36.1 cm. Early 14th century. Chōraku-ji, Gunma Prefecture.*
130. *(center) Kōetsu:* Landscape. *Late 15th or early 16th century.*
131. *(right) Keison:* Reading by Moonlight. *Late 15th or early 16th century.*

in Kamakura, he went to Kyoto in 1478. Three years of study with Geiami also afforded opportunity to study the shogunal collection of Chinese paintings, of which Geiami was supervisor. When Kei Shoki was about to return to Kamakura, Geiami gave him as a parting gift his *Viewing a Waterfall* (Plate 112). In the inscription to this painting, the monk Osen Keisan states that Kei's technique had greatly improved as a result of his three years in Kyoto, and certainly it was this period of study which established Kei as an ink painter of national stature.

His paintings *Birds and Flowers* (Plate 110), *Mt. Fuji* (Plate 127), *Cottage of the Evening Bell* (Plate 128), and *Horse and Groom* (Plate 125) reveal assiduous study of Sung painting and considerable refinement of the rougher style he had learned from Chūan Shinkō.

Painted in 1506, *Cottage of the Evening Bell* was inscribed by two Kenchō-ji monks, Gyokkan Eiyo and Shōshun. Paintings on the theme of the scholar's retreat were popular in Kyoto *gozan* monasteries beginning in the early fifteenth century, and Kei Shoki may have introduced the genre to Kamakura. Kei's best work is probably the landscape in the Nezu Museum collection (Plate 114), a fine example of Kamakura painting, which in its execution is as sophisticated as anything then being produced in Kyoto. His students include Keison (see Plate 131), Keisō, Keisessai (see Plate 126), Kōetsu (Plate 130), Senka, and Shikibu Terutada (known as Ryūkyō). Shikibu is known to have painted a number of large folding screens. All share, as an almost ineluctable mark of the Kamakura tradition, a rather antique, provincial

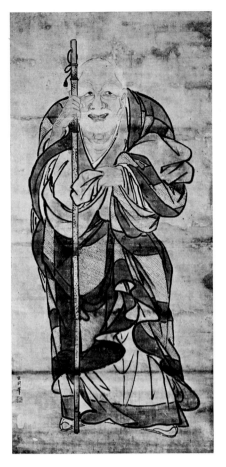

132. Sōen: Bhadrapāla. *Ink and colors on paper; ht 161, w 74 cm. Early 16th century. Engaku-ji, Kamakura.*

quality that only Kei himself seems to have transcended.

One Kamakura ink painter who should not be forgotten is the Engaku-ji monk Sōen, or Jōsui, whose style was modeled on that of Sesshū and who was one of Sesshū's favorite disciples. Examples of Sōen's landscapes, bird and flower paintings, and *haboku* exist, as well as an unusual figure study in the Sesshū style of Bhadrapāla (Plate 132), the deity of Zen monastery bathrooms.

With regard to the state of ink painting in the provinces, mention has already been made of Sesshū's circle in Yamaguchi and of the solitary genius Sesson in northern Japan. By the mid-Muromachi period, ink painting was also spreading from Kamakura to its outlying districts. One group of painters, popularly referred to as the Odawara Kanō, was active in the small town of Odawara at the head of the Izu peninsula. The names of some of the group—Gyokuraku, Shikibu Gyoshi, Kin Gyokusen—are known, although none of their work survives. It was out of this small group, however, that the Kanō school, one of the most numerous and influential in the history of Japanese painting, was to emerge.

7

The Kanō School

The *Kanō Family Genealogy,* an Edo-period document, traces the origin of the family back via Kanō Masanobu (1434–1530), the first great Kanō painter, to Muneshige, a warrior of the Izu district who served Minamoto no Yoritomo (1147–99), the founder of the Kamakura *bakufu.* According to the same genealogy, Kagenobu, Masanobu's father, was a retainer of the Imagawa, the leading family in the Izu-Shizuoka region under the Ashikaga *bakufu.* Kagenobu is said to have come to the attention of the Ashikaga when he painted a view of Mt. Fuji for the sixth shogun, Yoshinori (1394–1441), on the occasion of a visit by Yoshinori to Imagawa Norimasa's residence in order to view the imposing mountain. It was probably on the strength of this connection that Masanobu later came to serve the Ashikaga as an official painter, or *goyō eshi,* at the capital in Kyoto.

Masanobu

Masanobu's work is well documented. The first mention occurs in the *Onryōken Nichiroku* for 1463 and refers to *Kannon and Rakan,* painted by Masanobu on the walls of one of the halls of the Unchō-in, a subtemple of Shōkoku-ji. Of the numerous works by Masanobu listed in the *Onryōken Nichiroku,* color portraits predominate: posthumous portraits of the courtiers Fujiwara Yoshitsune and Fujiwara Michiie (1486); of Ashikaga Yoshihiro, Yoshihiro in armor, and the monk Kisen Shūchō, compiler of the later sections of the *Onryōken Nichiroku* (1486); of Ashikaga Yoshimasa (1490); and yet another of Yoshihiro

in armor (1491). Mention is also made of a number
of Buddhist votive paintings by Masanobu: a paint-
ing of ten monks done in 1484 for Yoshimasa's Hi-
gashiyama villa near Kyoto, and a painting of the five
Esoteric Buddhist deities commissioned by Kisen
Shūchō in 1486. Other records mention a portrait of
Hino Tomiko, Yoshimasa's wife, painted in 1496,
and a painting of the Buddha entering Nirvana, paint-
ed in 1487 for Yoshimasa's private votive hall and
study on the grounds of his Higashiyama villa.

It is significant that ink paintings by Masanobu re-
ceive very little mention in contemporary documen-
tary sources. The *Onryōken Nichiroku* does mention a
fusuma painting by Masanobu in the Gansei-in (1492),
and the monk Osen Keisan, in one of his poems,
refers to paintings of the eight views of Hsiao-Hsiang
by Masanobu on *fusuma* in Yoshimasa's mountain
temple of Jōdo-ji at Higashiyama. But these are almost
the only records of Masanobu as an ink painter. In
part, this is because his maturity coincided with the
apogee of the largely Zen-inspired Higashiyama cul-
ture, which focused on Yoshimasa's retreat in the
Eastern Hills. In terms of both quality and numbers,
the final quarter of the fifteenth century was in many
respects the high point of Muromachi *suibokuga*. Oguri
Sōtan had succeeded Shūbun as shogunal painter.
Sesshū had returned from China and was producing
some of his greatest masterpieces. Nōami died in 1471
and Sōtan in 1486; but Geiami, Sōami, Jasoku, and
Gakuō remained active. Masanobu was thus only one
among a brilliant coterie of painters.

In addition, paintings, especially landscape and bird
and flower paintings, which were thought to call for
a high level of taste and aesthetic sensibility, were
still entrusted mainly to Zen monks or to those who
had undergone Zen discipline. The more pedestrian
subjects given by the *bakufu* to professionals like Masa-
nobu who lacked such a Zen background (the Kanō
were Nichiren followers) were mainly Buddhist
votive themes and portraits to be used at certain Zen
ceremonies. It is ironic, however, that in spite of the
sparse documentary references to ink paintings by

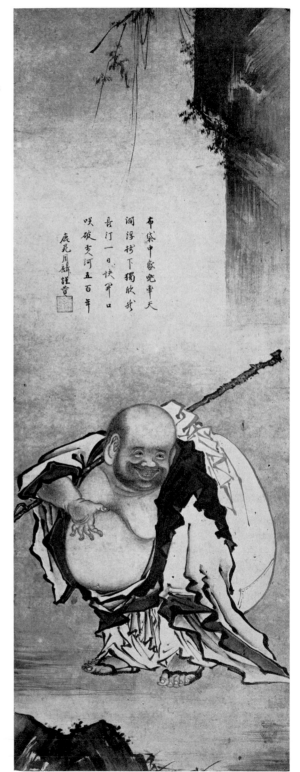

133. *Kanō Masanobu:* Pu-tai. *Inscription by Keijo Shūrin.
Late 15th century. Kuriyama Collection, Tokyo.*

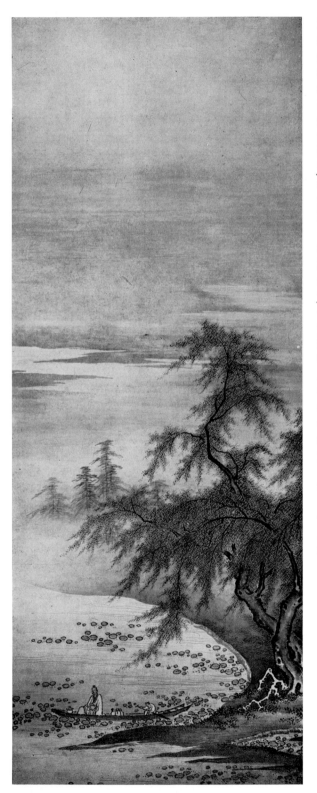

Masanobu and his reportedly great output of "professional" works, the few paintings of his which survive are all landscapes, bird and flower paintings, or figure studies in the Zen tradition, and that these were instrumental in shaping the Kanō school style. The Shinju-an, a subtemple of Daitoku-ji, owns a folding screen decorated with a painting attributed to Masanobu called *Bamboo and White Crane*. He is also credited with several ink landscapes; a figure study of a jovial Pu-tai with an inscription by the monk Keijo Shūrin (d. 1518; Plate 133); and the tranquil, lucid painting of the Northern Sung man of letters Chou Mao-shu admiring lotus flowers (Plate 134).

Lucidity characterizes Masanobu's paintings and distinguishes them from the more "knotty," directly Zen-inspired ink paintings that had hitherto predominated. Consciously or unconsciously, Masanobu rejected some of the most vital qualities of Zen painting —purposeful irony and paradox, deliberate incompleteness, intellectual challenge—in favor of a simpler, more direct presentation. That Masanobu also had a taste for the decorative or ornate is apparent from the *Bamboo and White Crane* screen. These two strands of simplicity of presentation and love of the ornate evident in the work of Masanobu became hallmarks of the Kanō school and marked a further stage in the acculturation of ink painting. It became more comprehensible and familiar to warriors and nobles of the day, many of whom did not have rigorous grounding in Zen.

Masanobu had a variety of names and honorific titles. He is first mentioned as Kanō Shōgen, then as Kanō Osuinosuke. He did not take the name Masanobu until he was nearly sixty. His titles also included those of Echizen no Kami, or Governor of Echizen, and the Buddhist honorific title of Hokkyō, or Bridge of the Law. Masanobu outlived Sesshū and Sōami, and by the time of his death in 1530 his son Motonobu (1476–1559) was well established as a major painter and the central figure of the burgeoning Kanō school. Of Masanobu's two sons, Yukinobu, the younger, died young. The only paintings of his still existing are

134. *Kanō Masanobu:* Chou Mao-shu Admiring Lotus Flowers. *Ink and colors on paper; ht 85, w 33 cm. National Treasure. 16th century. Nakamura Collection, Tokyo.*

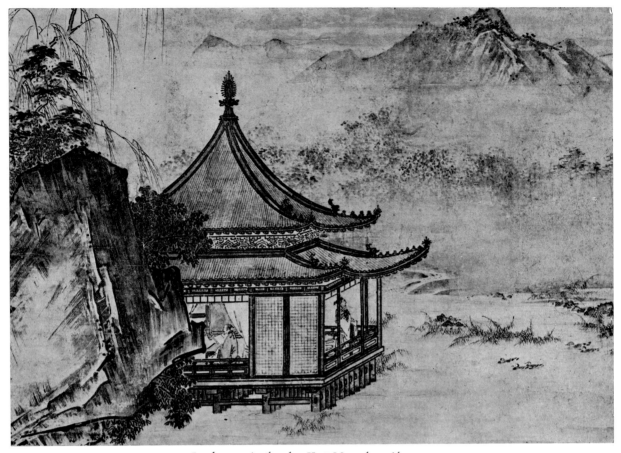

135. Landscape. *Attributed to Kanō Motonobu. 16th century.*

landscapes in his father's style originally painted for *fusuma* in the abbot's quarters *(hōjō)* at Daisen-in. Motonobu, the elder son, long-lived like his father, set the Kanō school firmly on its feet and fixed its distinctive style.

Motonobu

The abbot's quarters in the Daisen-in built in 1509 is one of the oldest remaining Zen monastic *hōjō*. Its panels were originally decorated with paintings by Sōami and Kanō Motonobu as well as Yukinobu. This commission was Motonobu's earliest recorded work. Now mounted as hanging scrolls, the paintings (Plate 115) provide a glimpse of Motonobu's style

when he was in his early thirties. In their rather stiff angularity, they show the influence of Ma Yüan, and blend ordinary landscape style with the type of landscape background frequently found in ink paintings depicting scenes from the lives of the Zen patriarchs *(zenkizu)*. Touches of color, however, relieve the somber quality sometimes seen in Zen didactic paintings (see also Plate 135).

As he grew older, Motonobu made greater use of color and decorative effect. According to some scholars Motonobu married the daughter of Tosa Mitsunobu, the head of the Tosa school of painters in the *yamato* style, and contact with the Tosa school may have increased Motonobu's interest in the use of color. Even if he was not directly influenced by Tosa paint-

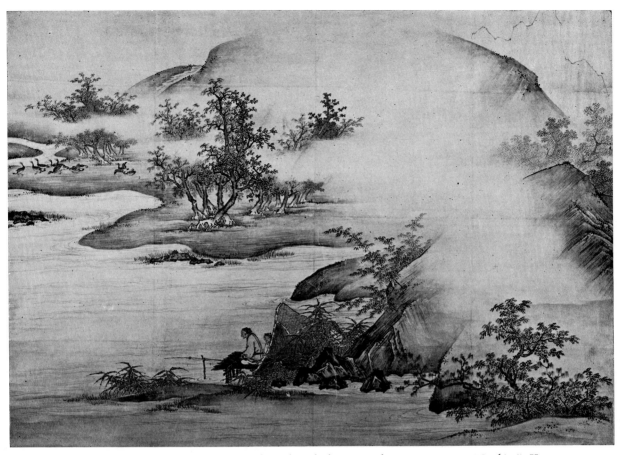

136. *Kanō Motonobu:* Landscape with Birds and Flowers. *16th century. Reiun-in, Myōshin-ji, Kyoto.*

ers, he did paint a number of horizontal scrolls in the *yamato* manner, among them the *Kurama-dera Engi* and, allegedly, the *Seiryō-ji Engi,* and this practice in *yamato-e* probably contributed to the simpler, brighter note characteristic of his work. The *fusuma* paintings in the Reiun-in of Myōshin-ji, *Landscape with Birds and Flowers,* painted in 1543 when Motonobu was in his late sixties, are typical of his style in being thoroughly Japanese in feeling (Plate 136). In his later years Motonobu painted a number of bird and flower screen paintings in vivid colors on gold ground. This type of painting appealed to the newly rising warrior leaders and became extremely popular during the Momoyama period (1568–1603).

Of Motonobu's three sons, Munenobu, Hideyori, and Shōei Naonobu, Hideyori is the most interesting. While continuing to work in the *suiboku* tradition, Hideyori also produced some very Japanese genre paintings based on local festivals and seasonal entertainments. His major work, the vivid screen painting *Viewing Maples at Takao,* is a landmark in the development of Japanese decorative painting. The mainstream of the Kanō school, however, ran via Naonobu, who was neither particularly original nor particularly talented, to his son Eitoku (1543–90), who was by far the most prolific and important painter of the Momoyama period, being *goyō eshi* to both Oda Nobunaga (1534–82), and Toyotomi Hideyoshi (1536–98).

8

Later Painters:
The Momoyama and Edo Periods

The Ashikaga *bakufu,* although debilitated by the Onin rebellion and ensuing wars, clung to power until Oda Nobunaga, in a drive for national hegemony, swept into Kyoto in 1568. Nobunaga was assassinated in 1582 by his retainer Akechi Mitsuhide, who only ten days later was himself defeated by Toyotomi Hideyoshi. At lower levels of society, too, warriors continued to turn on their erstwhile overlords until the Tokugawa imposed their authority at the battle of Sekigahara in 1600.

Changes in Taste

Although the history of the later sixteenth century is violent, it is more than simply a catalog of wars and bloodshed. While warriors were struggling to advance their fortunes by the sword, the townsfolk of cities like Sakai enjoyed a period of considerable prosperity and relative freedom. Christianity, brought to Japan by Francis Xavier in 1549, was spreading, helped by the tolerant attitude of Nobunaga and Hideyoshi, who were bent on curbing the power of the more militant Buddhist sects. Christian missionaries were accompanied by European merchants, and Japan, hitherto restricted to direct contact with only the culture of China and Korea, was, for a century, offered a taste of Western culture. The *gozan* monasteries suffered relative eclipse with the decline of their Ashikaga patrons. The Chinese learning and arts in which the *gozan* excelled were challenged by the novel culture of the West and by a quickened interest in things Japanese.

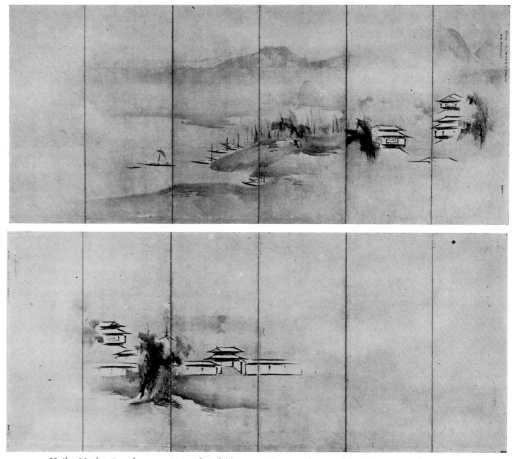

137. Kaihō Yūshō: Landscapes. *Pair of sixfold screens. Late 15th or early 16th century. Atami Art Museum.*

These political and social changes reverberated through the arts. Nobunaga, Hideyoshi, and Tokugawa Ieyasu, who were less interested in Zen than the Ashikaga, had a taste for the grandiose and colorful as expressions of their personal, hard-won authority. The huge castles they built were intended as tangible symbols of their power and were decorated on a suitably sumptuous scale. In painting, the demand from warriors and merchants alike was now for vividly colored genre paintings depicting the lives and pleasures of the townsfolk. Such works were produced in great numbers by members of the Kanō school and also by urban artisan-painters. Western styles of painting promoted by Christianity, until its suppression by the Tokugawa, introduced new colors, new styles, and new iconographic motifs.

Ink painting was no more immune to change than any other branch of the arts. By the time Nobunaga thrust his way to power in the 1560s, most of the leading Muromachi-period painters were dead; only Sesson was active in the north. New men were establishing reputations for themselves, responding successfully to the changes in patronage and taste. Perhaps the greatest change in *suibokuga,* however, was one of inner values. By the Momoyama period, ink paintings were no longer required or expected to express the spiritual depths of the painter's inner vision. It was sufficient for them to take as their subject the world of external day-to-day reality, to portray things as they appeared rather than as they were felt to be. Moreover, conscious restraint in color and mood was giving way to a frank enjoyment of less

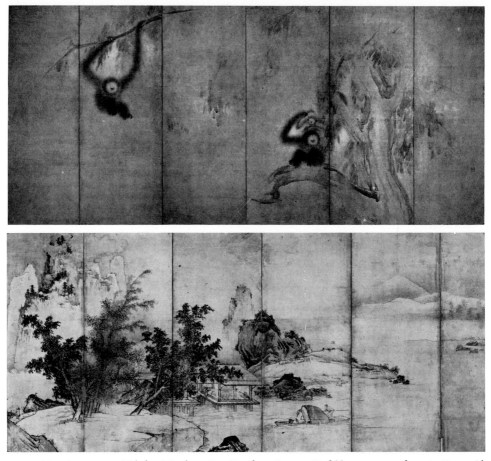

138. *(above) Hasegawa Tōhaku:* Monkeys in a Bamboo Grove. *Sixfold screen, one of a pair. Late 16th or early 17th century. Shōkoku-ji, Kyoto.*

139. *Unkoku Tōgan:* Landscape with Figures. *Sixfold screen. 16th or 17th century.*

subdued, almost gaudy paintings. This shift in the direction of the overt, tangible, and ornate was hastened by the much larger scale of the surfaces provided in the massive chambers of the new castles not only for *dami-e,* or colored murals, but also for *suibokuga.*

The era in which *suibokuga* was the dominant force in Japanese painting had passed; new styles were to emerge in response to changing social and aesthetic needs. The Kanō decorative schools, the Rimpa stream, *ukiyo-e,* and literati painting all flourished in the Edo period (1603–1868). But the achievements of the leading *suibokuga* masters had become part of the national heritage and later artists, even those in far different schools, drew upon Sesshū or Sesson or Motonobu for inspiration.

Momoyama Painters

Kanō Eitoku (1543–90), *goyō eshi* to Nobunaga and Hideyoshi and foremost painter of the day, was active in all branches of painting. His ink paintings, befitting the stature of his patrons, were frequently grand in conception and highly decorative, including pine or plum trees with powerful trunks and branches spreading six or seven meters, and near life-size human figures on brilliant gold ground. Eitoku's *fusuma* paintings from the abbot's quarters in the Jukō-in in Daitoku-ji (Plate 118) of a large plum tree and birds on gold ground show a powerful decorative style that was in keeping with the new taste. Eitoku is also believed to have painted *suiboku* murals as well as

140. *Tawaraya Sōtatsu:* Oxen. *Pair of hanging scrolls. Ink on paper; ht 96.5, w 44.3 cm each. Early 17th century. Chōmyō-ji, Kyoto.*

dami-e in Nobunaga's Azuchi Castle (1581) and in Hideyoshi's Osaka Castle (1583) and the Jurakudai in Kyoto (1587). Unfortunately, none of these survive.

Kaihō Yūshō (1533–1615), a retainer of the Asai family, became a painter at about the age of forty after the destruction of the family. It is not clear when or with whom he actually studied ink painting, but his works, though characteristically his own, show familiarity with Eitoku and the Southern Sung painters, especially Liang K'ai. His greatest achievement, done when he was nearly seventy and now surviving in the form of hanging scrolls, was the series of murals painted in the abbot's quarters of Kennin-ji in Kyoto. The *Pine Tree and Peacock* painting (Plate 141) from the tokonoma (alcove), especially, is as monumental

as anything painted by Eitoku. On the *fusuma* Kaihō painted a number of outline figures—obviously favorite subjects of his—in the abbreviated style of Liang K'ai's painting of Li Po. Under Kaihō's brush, however, the rather severe Liang K'ai figures become gentler and more human, and a note of dry humor can even be detected. A number of landscapes, bird and flower paintings, and figure paintings by Kaihō also survive. His interest in these subjects was probably stimulated by contact with Zen monks when, as a warrior, he practiced Zen in Tōfuku-ji. In his treatment of the Liang-K'ai-style figures on the Kennin-ji *fusuma,* Kaihō was conforming to current taste. His landscapes, too (Plate 137), though clearly influenced by the style of the Southern Sung painter Yü Chien, had

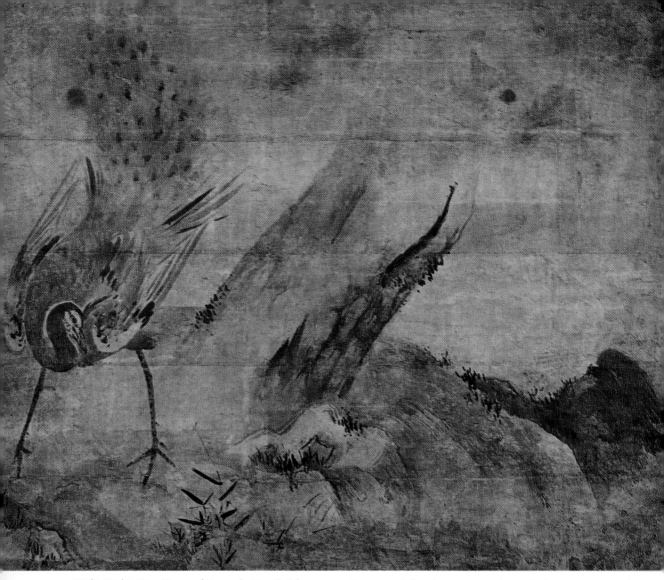

141. *Kaihō Yūshō:* Pine Tree and Peacock. *Detail. Ink on paper. Important Cultural Property. Kaihō Yūshō became a recognized painter only in middle age. For much of his life, he served the Asai family of Omi as a samurai retainer, and it was only after their downfall that he entered Tōfuku-ji to practice Zen and there began to study painting under Kanō Eitoku. He also learned much through careful examination of the work of the Chinese masters Liang K'ai and Yü Chien. The work shown here, originally painted in the alcove or tokonoma of the abbot's quarters at Kennin-ji, is a good example of Momoyama-period taste. On the* fusuma *of the same chamber Yūshō painted a number of abbreviated outline figures in the manner of Liang K'ai, though gentler in expression than Liang K'ai's rather awesome study of Li Po (Plate 25). Late 16th century. Kennin-ji, Kyoto.*

142. *Hasegawa Tōhaku:* Pine Grove. *Detail. Ink on paper; two leaves from one of a pair of sixfold screens (byōbu); ht 155.6, w* ▷
346.9 cm each. National Treasure. These two screens display Tōhaku's work at its finest. By subtle variation of ink shading, fine brushwork, and skillful use of empty space, the artist palpably conveys the atmosphere of a pine wood wreathed in morning mist. Although in style the painting owes something to Mu Ch'i, the work is entirely Japanese in brushwork and softness of expression, and in keeping with Momoyama taste in its decorative use of the whole surface of the screens. Momoyama period, 17th century. Tokyo National Museum.

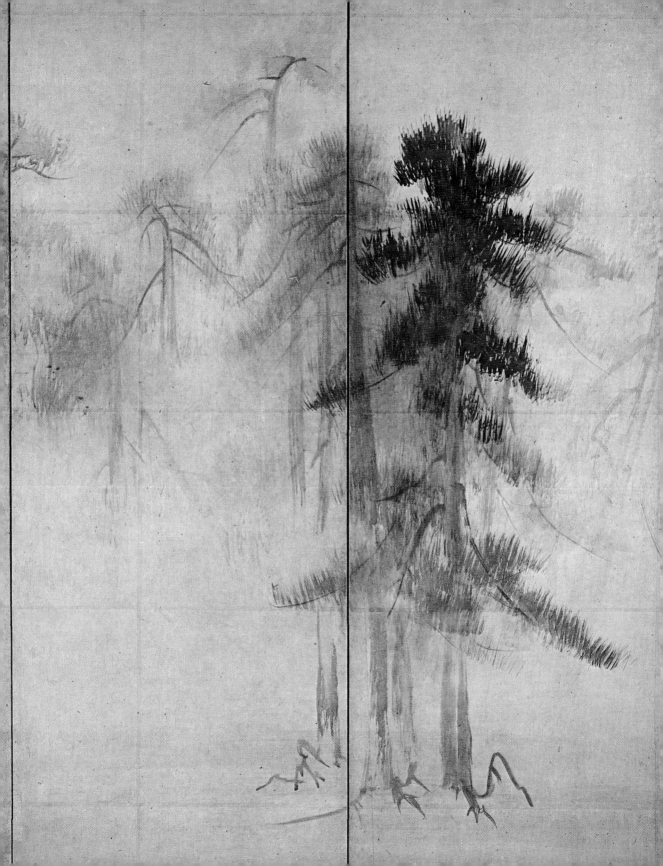

143. Ogata Kōrin: Plum and Bamboo. *Folding screen. Late 17th–early 18th century. Nojiri Collection, Kanagawa Prefecture.*

144. Ikeno Taiga: Arhats. *Ink and colors on paper; painted on the* fusuma *of Mampuku-ji. National Treasure. Late 18th century.* ▷
Mampuku-ji, Kyoto.

taken a very different direction from the *haboku* landscapes of Sesshū that derived inspiration from the same source.

Hasegawa Tōhaku (1539–1610), as a student of Sesshū's disciple Tōshun, described himself as being in the Sesshū tradition. Although he has left vividly colored paintings like those in the Chishaku-in, most of his extant works are *suibokuga*. He must have been a very rapid and prolific painter. Many of his works survive. Daitoku-ji, Myōshin-ji, and Nanzen-ji all possess *fusuma* paintings, murals, or *byōbu* (screens) by Tōhaku. Shōkoku-ji has the delightful *byōbu Monkeys in a Bamboo Grove* (Plate 138), and Tōhaku's *Pine Grove* screens (Plate 142) are in the collection of the Tokyo National Museum.

Tōhaku's paintings show the influence of Chinese and Japanese masters. Some of his landscapes and figure studies are in the Sesshū tradition, others are in the style of Hsia Kuei, and the *Monkeys* is inspired by Mu Ch'i (see Plate 52). The most characteristic Tōhaku paintings are the two sixfold *Pine Grove* screens (Plate 142), in which mist-shrouded pines are suggested simply by variations of ink shade. These screens, in their lyrical intensity and feeling for nature, are entirely Japanese in spirit and indicative of the extent to which ink painting was by now fully acclimatized. Judging from the style, they were probably produced at about the same time as the screens showing monkeys belonging to the Ryusen-an, which were painted when Tōhaku was fifty-seven.

Unkoku Tōgan (1547–1618), who revived Sesshū's painting studio, the Unkoku-an, was strongly influenced by Sesshū, but many of his landscapes seem formalized and wanting in vitality (Plate 139). The painting *Crows on a Plum Branch* (Plate 145), however, which could hardly have been painted in the Muromachi period but is entirely in keeping with Momoyama taste, effectively utilizes an expanse of gold ground to set off the ink-painted birds.

From this brief discussion of some of the major artists of the later sixteenth century it should be apparent that Momoyama-period ink painting, although it drew upon Muromachi *suibokuga* and Chinese ink-painting techniques, was distinguished by its straight-

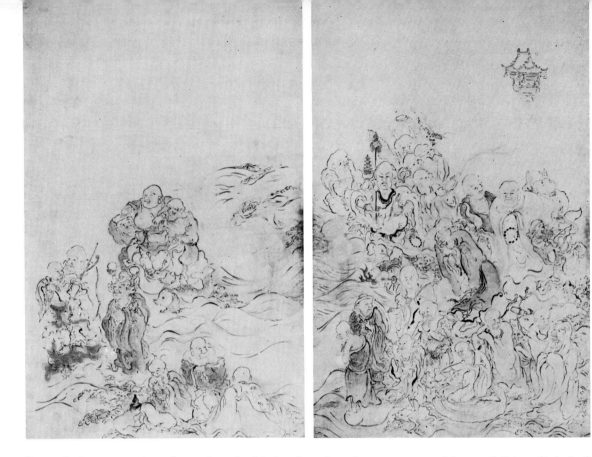

forward observation, lyrical mood, and gilded style.

Edo Painters

With the establishment of the Tokugawa *bakufu,* many Kanō school painters moved from Kyoto to Edo. Enjoying the patronage of the Tokugawa, the Edo Kanō family, under the leadership of the brothers Tan'yū, Naonobu, and Yasunobu, prospered as *goyō eshi.* Of the numerous Kanō painters, Tan'yū (Morinobu), Naonobu, and Kusumi Morikage (a disciple of Tan'yū who was later expelled from the school) deserve more mention as accomplished ink painters. Space is limited, however, and a few words at least should be devoted to the Rimpa painters Sōtatsu and Kōrin and to the introduction and development of the *wen-jen,* or literati, tradition in relation to the ink-painting tradition.

Tawaraya Sōtatsu (d. 1643) was trained in the *yamato-e* tradition, but through contact with merchants in Sakai who used imported Chinese ink paintings as hanging scrolls for the tea ceremony, he seems to have become aware of the possibilities of ink shading. His painting *Lotus Pond with Waterfowl* (Plate 146) clearly derives inspiration from Chinese paintings in its use of ink. Sōtatsu, in both color and ink paintings, made use of the *haboku* technique of Yü Chien or Sesshū, whereby the shade of ink is varied by adding darker ink over still-wet ink wash. Sōtatsu even developed this technique further into what is sometimes described as his *tarashikomi* or "puddling" technique. This technique is employed to fine effect in a way not seen in Chinese painting in his *Oxen* (Plate 140). By his use of *tarashikomi,* Sōtatsu conveys a detailed sense of the physical frame of the oxen and a forceful impression of bulk.

Ogata Kōrin (1658–1716), was greatly influenced by Sōtatsu, but through careful study of the styles of Sesson and Sesshū developed ink techniques unknown to Sōtatsu. Some of these techniques are apparent in the painting of branches in the famous *Red and White Plum Blossom* screens. The *Plum and Bamboo* screen (Plate 143) is also a fine example of the blending of gilt with ink. Sōtatsu and Kōrin combined some ele-

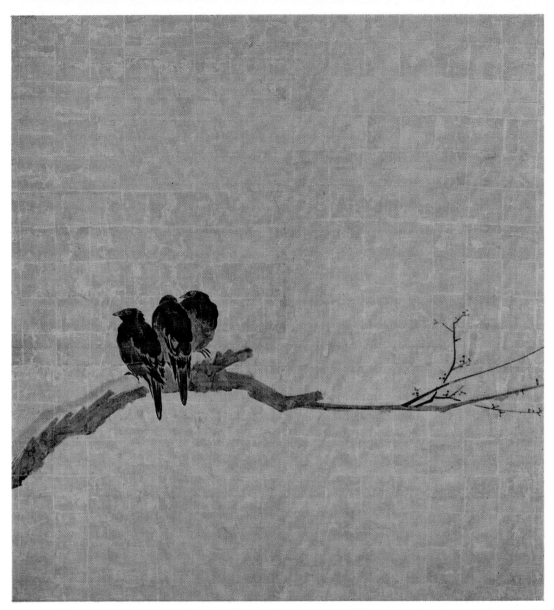

145. *Unkoku Tōgan:* Crows on a Plum Branch. *Detail. From a series of* fusuma *panels; colors and ink over gold ground on paper; ht 165, w 155.7 cm. Important Cultural Property. This is one of a series of six* fusuma *paintings that originally decorated a room in the Kuroda family villa in Chikuzen (Fukuoka). The birds and branches, painted in ink with touches of color to suggest blossoms and lichen, stand out vividly against the expanses of gold ground, and the total effect is at once daring and restrained. Late 16th–early 17th century. Kyoto National Museum.*

146. *Tawaraya Sōtatsu:* Lotus Pond with Waterfowl. *Ink on paper; ht 116, w 50 cm. National Treasure. Although* ▷ *the subject of this work derives from Chinese painting, the muted execution is thoroughly Japanese in taste and shows the extent to which ink painting had been acclimatized in Japan by the beginning of the Edo period. Sōtatsu developed a shading technique known as* tarashikomi, *which in this painting is most evident in the lotus leaves. Edo period, 17th century. Committee for the Protection of Cultural Properties.*

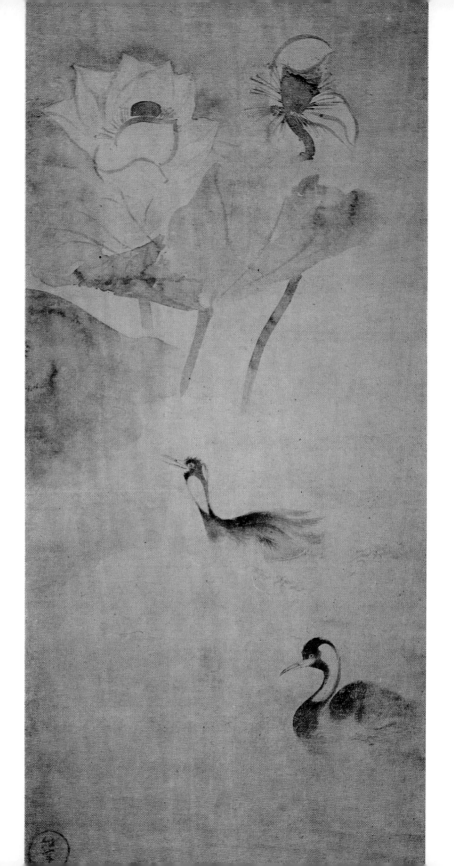

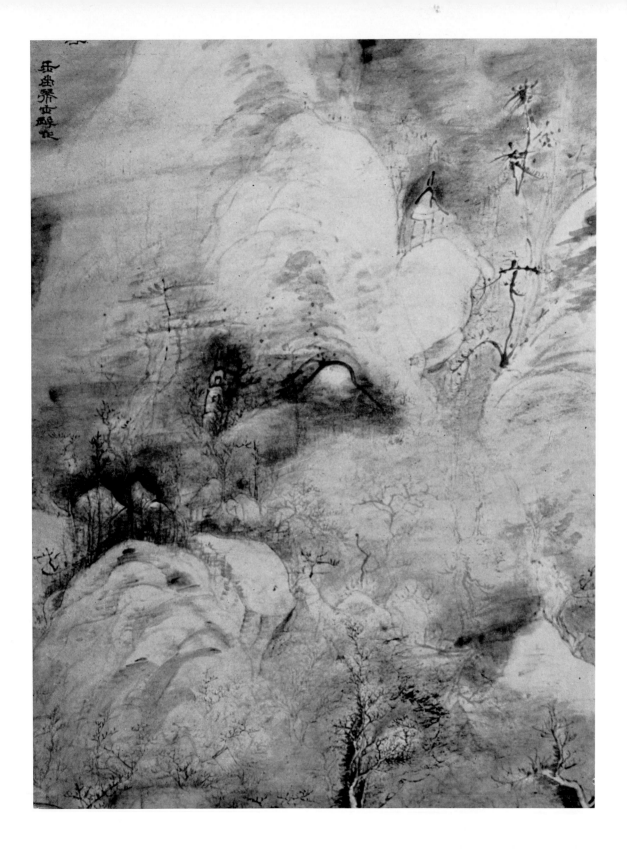

148. *Yosa Buson:* Night Scene. *Detail. 18th century. Mutō Collection, Hyōgo Prefecture.*

◁ 147. *Uragami Gyokudō:* Frozen Clouds and Whirling Snow. *Ink on paper; ht 133.4, w 56.2 cm. National Treasure. Early 19th century. Kawabata Collection, Kanagawa Prefecture.*

ments of the literati tradition with a highly decorative style. The Chinese *wen-jen* style, however, was not fully introduced into Japan until the eighteenth century and reached maturity only with Ikeno Taiga, Uragami Gyokudō, Gion Nankai, and Yosa Buson.

Literati paintings preserved most faithfully the original ideal of ink paintings as expressions of the state of mind of gentry or scholars who were not painters by profession. Although the tradition of literati painting had a long and unbroken history in China, it was slow in spreading to Japan. Circumstances were favorable in the mid-Tokugawa period, however, when a renewed interest in *wen-jen* painting in China attracted Japanese attention. Although Tokugawa rule was ponderous in many respects, its Confucian-based ideology and the long period of peace and stability that it made possible were favorable to cultural development. Numerous Confucianists, scholars, and physicians attached to the various feudal district governments, or *han,* as well as unattached scholars and townsmen, began to experiment in the literati style.

Gion Nankai (1677–1751), for instance, Confucian teacher to the Wakayama *han,* poet and painter, was one of the pioneers of *wen-jen* painting in Japan. Ikeno Taiga (1723–76), a native of Kyoto, studied the work of Nankai as well as Chinese *wen-jen* paintings. In the best *wen-jen* tradition, Taiga also read widely and traveled tirelessly about Japan in order to deepen his understanding of the varied moods of nature and human emotions. He was thus instrumental in shaping the distinctively Japanese literati style of painting (Plate 144) called *bunjinga.*

Uragami Gyokudō (1745–1820), a samurai from Bitchū (present-day Okayama Prefecture), left his *han* at the age of fifty with his *koto* (long harp) as companion and wandered the country, studying the passing scene, painting (Plate 147), and entertaining friends with music. The earthy *haiku* poet and painter Yosa Buson (1716–83; Plate 148) was also a wanderer.

Although these painters differed in personality and style, all are solidly in the *wen-jen* tradition in their ability to catch and convey the spirit of things, not merely their outward form. Moreover, their work shows, in a new incarnation, unmistakable traces of the techniques and spirit of *suibokuga.*

Glossary

azana: pen name adopted by a poet or man of letters; the familiar name given to, or adopted by, a Zen monk

bakufu: government institutions of warrior overlords (shoguns). Warriors seized effective political authority from the imperial court and nobles in the late twelfth century and held it until the mid-nineteenth. During this period three major warrior "dynasties" were established and overthrown: the Kamakura *bakufu* (1185–1336), the Ashikaga or Muromachi *bakufu* (1336–1568), and the Tokugawa or Edo *bakufu* (1603–1868).

bunjinga: paintings by literati *(wen-jen),* or in the literati tradition

byōbu: two-, four-, or sixfold paper- or silk-covered standing screens, usually decorated with calligraphy or paintings and produced in matching pairs

chinzō: realistic, formally posed color portraits of eminent Zen masters in ceremonial robes. *Chinzō* frequently bear an inscription by the subject and were in some instances painted to be given as tokens of recognition and favor by masters to their disciples. Although *chinzō* do not come within the scope of ink painting proper, some *chinzō* contained features that influenced ink painters.

daimyo: a feudal lord, owing allegiance to the shogun

Daitoku-ji: Kyoto Rinzai monastery, temporarily included in the *gozan.* Daitoku-ji was patronized initially by Emperors Hanazono and Godaigo and later by wealthy merchants of Sakai. From the mid-fifteenth century it became an important center for the encouragement of the tea ceremony and ink painting.

dami-e: "thick painting"; vividly colored, large-scale murals decorating the walls of Momoyama-period castles and palaces

dōshakuga: paintings illustrating the exploits of Taoist *(dō)* immortals or Buddhist *(shaku)* monks

ebusshi: masters of Buddhist painting; originally court painters who specialized in Buddhist subjects. During the Kamakura period *ebusshi* are also found in the painting ateliers of large monasteries. Zen monks who engaged in painting, though they shared—in the case of the Tōfuku-ji painters at least—some of the characteristics of *ebusshi,* are generally referred to in Japanese as *gasō,* painter-monks.

eshi: master painter; painters of secular themes attached to the court in the Nara and Heian periods

fusuma: paper-covered panels used as sliding doors, partitions, and interior walls in Japanese buildings

fusuma-e: paintings on *fusuma* panels. The use of *fusuma* allowed a room or series of rooms to be decorated throughout in a carefully planned sequence of paintings.

gozan: "five mountains"; originally the five monasteries that headed the hierarchy of official Zen monasteries in Sung China. This system was copied, with some variation, in Japan, where five Kamakura and five Kyoto monasteries were designated *gozan.* In the fully articulated system the Kyoto *gozan* (in descending order of seniority) were Tenryū-ji, Shōkoku-ji, Kennin-ji, Tōfuku-ji, and Manju-ji; their Kamakura counterparts were Kenchō-ji, Engaku-ji, Jufuku-ji, Jōchi-ji, and Jōmyō-ji. The important Kyoto monastery of Nanzen-ji was placed at the apex of this parallel system, but the center of authority for the whole *gozan* system really lay within one of the subtemples of Shōkoku-ji.

gozan bungaku: gozan literature; Chinese poetry, diaries, etc., written by Japanese *gozan* monks

haboku: "broken ink" style, in which shade of ink is varied by use of alternating thick, then thin lines and ink washes to convey nuances of texture, mood, and movement in the painting

haiku: seventeen-syllable Japanese verse

han: districts under daimyo authority in the Edo period

hatsuboku: "splashed ink" style in which the painter splashes and splatters ink, allowing the painting almost to shape itself

hōjō: the abbot's quarters in a Zen monastery

imina: the formal name given to a Zen monk at ordination

Kannon: Avalokiteśvara; Kuan Yin. Buddhist deity of encompassing compassion. The white-robed Kannon, one of the many manifestations of Avalokiteśvara, was particularly popular with Zen practitioners because of its association with meditation and enlightenment. The white robe symbolizes purity and a mind of perfect enlightenment.

kōan: pithy, seemingly nonsensical problem used especially by Rinzai Zen masters to stimulate intuitive understanding in their students

koto: thirteen-stringed horizontal harp

Kyōgen: farcical or satirical sketches that developed as a dramatic form during the Muromachi period. Unlike Nō actors, Kyōgen actors usually do not wear masks.

nembutsu: repeated invocation of the name of one of the Buddhas, principally Amida, in order to be reborn in his Pure Land

Nō: classical masked dance drama

rakan: arhat; in the Hinayana Buddhist tradition, a saint who has freed himself through meditation and austerities from the cravings of life and the bondage of rebirth

Rimpa: the Edo-period school of painters deriving from Ogata Kōrin

Rinzai Zen: The Zen tradition deriving from the Chinese master Rinzai; introduced into Japan by Eisai to become the dominant Zen sect in Kyoto and Kamakura. Rinzai made use of the *kōan* and *katsu* or shout as aids in shocking his students out of rational habits of thought into intuitive self-understanding.

shigajiku: works in which painting and poetry fuse to illuminate a single theme; known as poetry and painting scrolls

shogun: theoretically, the supreme military agents of the emperors; actual rulers of Japan during the centuries of warrior control

Sōtō Zen: the Zen teachings and practice introduced to Japan by Dōgen which stressed *zazen;* spread widely in the provinces among lower ranking warriors and played a much less significant role in the introduction and encouragement of ink painting than the metropolitan Rinzai schools

suibokuga: painting in ink on paper or silk

tarashikomi: an ink-painting technique involving the application of wet ink over still damp ink to produce impressions of depth, bulk, shade, etc.

tokonoma: an alcove in a Japanese room used for the display of a hanging scroll, flowers, tea-ceremony utensils, etc.; developed from the Buddhist altar as an important feature of Japanese residential architecture in the Muromachi period

ukiyo-e: paintings of the floating world; genre paintings and prints, especially those during the Edo period

wen-jen: see *bunjinga*

yamato-e: color paintings in the *yamato,* or Japanese, tradition

zenkizu: didactic paintings on Zen themes

Bibliography

Works in English

Akiyama, Terukazu: *Japanese Painting*. Lausanne: Skira, 1961.

Awakawa, Yasuichi: *Zen Painting*. John Bester (tr.). Tokyo: Kodansha International, 1970.

Bush, Susan: *The Chinese Literati on Painting*. Cambridge, Mass.: Harvard University Press, 1971.

Cahill, James: *Chinese Painting*. Lausanne: Skira, 1960.

Covell, Jon Carter: *Under the Seal of Sesshu*. New York: DePamphilis Press, 1941.

Fontein, Jan, and Money Hickman: *Zen Painting and Calligraphy*. Boston: Museum of Fine Arts, 1970.

Hall, John Whitney: *Japan from Prehistory to Modern Times*. New York: Delacorte Press, 1970.

Hisamatsu, Shin'ichi: *Zen and the Fine Arts*. Gishin Tokiwa (tr.). Tokyo: Kodansha International, 1971.

Paine, Robert Treat, and Alexander Soper: *The Art and Architecture of Japan*. Penguin Books, 1955.

Reischauer, Edwin O., and John K. Fairbank: *East Asia The Great Tradition*. Boston: Houghton Mifflin, 1958.

Rosenfield, John M., and Shūjirō Shimada: *Traditions of Japanese Art*. Cambridge, Mass.: Harvard University Press, 1970.

Sickman, Laurence, and Alexander Soper: *The Art and Architecture of China,* rev. ed. Penguin Books, 1968.

Sirén, Osvald: *Chinese Painting,* 7 vols. London, 1955–58.

Suzuki, Daisetsu T.: *Zen and Japanese Culture*. Bollingen Series No. 64. New York: Bollingen Foundation, 1959.

Tanaka, Ichimatsu: *Japanese Ink Painting, Shubun to Sesshu*. Bruce Darling (tr.). New York and Tokyo: Weatherhill/Heibonsha, 1972.

Van Briessen, Fritz: *The Way of the Brush*. Tokyo: Tuttle, 1962.

Works in Japanese

(with illustration captions in English)

Matsushita, Takaaki: *Muromachi Suibokuga*. Tokyo: Muromachi Suibokuga Kankō-kai, 1960.

Tanaka, Ichimatsu, and Tanio Nakamura: *Sesshū, Sesson*. Vol. 7, *Suiboku Bijutsu Taikei*. Tokyo: Kōdansha, 1973.

Tanaka, Ichimatsu, and Yoshiho Yonezawa: *Suibokuga*. Vol 11, *Genshoku Nihon no Bijutsu*. Tokyo: Shōgakkan, 1970.

Index

Ami painters, the, 100; as classifiers, 101–02; as connoisseurs and critics, 103; as ink painters, 104, 107; *see also* Geiami, Nōami, Sōami

Ashikaga shoguns: and the Ami, 100–01; as patrons of the arts, 31, 32, 46, 48

Bodhidharma, 77; depictions of, 24, 28, 37, 83, 95; as historical person, 20; iconography of, 34; *see also* ink-painting themes, Zen

Bokkei, *see* Soga Jasoku

Bokusai, 99–100; illustration of work of, 78

bunjinga, see literati painting

Bunsei, 69, 93–94; illustrations of work of, 92, 93

Buson, *see* Yosa Buson

Butsunichi-an Komotsu Mokuroku, 45, 110–11

China, influence of, *see* Chinese ink painters; Chinese ink painting; Zen

Chinese ink painters: development of ink painting by, 13, 15, 17; *see also* Chinese ink painting; *individual artists;* ink-painting techniques

Chinese ink painting: categorization of, 57, 60, 101–02; as model, 45–47, 103–04, 110–13

Chü Jan, 15, 47; illustration of work of, 15

Chūan Shinkō, 117, 119; illustrations of work of, 113, 116

Daitoku-ji, *see* Kyoto monasteries

Enichibō Jōnin, illustration of work of, 39

Fan K'uan, 15; illustration of work of, 16

Feng Kan, 21, 26; depictions of, 25, 58; *see also* ink-painting themes, Zen

Gakuō Zōkyū, 69; illustrations of work of, 68

Geiai, *see* Oguri Sōritsu

Geiami, 100, 101; illustration of work of, 107; *see also* Ami painters, the

gozan: as literary movement *(gozan bungaku),* 29, 53, 55; as system, 31, 89–90; *see also* Kamakura monasteries; Kyoto monasteries; Zen

Gukei Jō-e, 48, 117

Gyokuen Bompō, 48, 55, 60; illustration of work of, 50

Gyomotsu On'e Mokuroku, 46, 101, 102

Han-shan and Shih-te, 21, 26, 43; depictions of, 38, 96, 116; *see also* ink-painting themes, Zen

Hasegawa Tōhaku, 44, 132; illustrations of work of, 128, 131

Honchō Gashi, 87, 95

Hsia Kuei, 17, 47; illustrations of work of, 17, 20

Hui Tsung, 47; illustration of work of, 46

Hui-neng, 20, 34–35; depiction of, 31

Ikeno Taiga, 137; illustration of work of, 133

Ikkyū, 90; depictions of, 78, 97; links with Jasoku-Bokkei, 95, 98

ink-painting techniques: *chen-t'i* style, 104; *haboku,* 15; *hatsuboku,* 15; *mo-ku* ("boneless") style, 103, 104, 107; *see also*

Chinese ink painters; *under individual artists;* Korea, influence of
ink-painting themes, non-Buddhist: flowers and birds, 38; Hsiao-Hsiang landscapes (eight views), 35, 103–04; orchid, 35, 38; plum blossom, 35
ink-painting themes, Taoist and Confucian: literary themes, 51–52; scholar's retreat, 51, 56–57, 60; the Three Doctrines, 49–50, 53, 55–57
ink-painting themes, Zen: Bodhidharma, 26, 34, 77; Feng Kan, 21, 26; Han-shan and Shih-te, 21, 43; Pu-tai, 21, 26, 123; Sākyamuni emerging from austerities, 42; white-robed Kannon, 44, 104
I-shan I-ning, 29, 35

Jakushitsu Genkō, 57, 60
Josetsu: and *Catfish and Gourd,* 48–49; documentary information on, 48, 50–51; illustrations of work of, 49, 52–54, 62; style of, 60

Kaihō Yūshō, 129, 132; illustrations of work of, 127, 130
Kamakura monasteries, 29, 31, 110–13; links with Kyoto, 117, 119; *see also gozan,* as system
Kanō, the, 120; *see also under individual artists*
Kanō Eitoku, 125, 128–29; illustration of work of, 112
Kanō Hideyori, 125
Kanō Masanobu, 121–23; illustrations of work of, 122–23; style of, 123
Kanō Motonobu, 123–25; illustrations of work of, 109, 124–25
Kao K'o-kung, 17, 47; illustration of work of, 21
Kaō Sōnen, 42–43; illustrations of work of, 38
Keisessai, 119; illustration of work of, 118
Kei Shoki, 104, 107, 117; disciples of, 119; illustrations of work of, 105, 108, 117–18; as painter, 119–20
Keisō, 119
Keison, 119; illustration of work of, 119
Kichizan Minchō, *see* Minchō
Kitano Tenjin, *see* Sugawara Michizane
Kōetsu, 119; illustration of work of, 119
Korea, influence of, 64, 67, 94
Kōrin, *see* Ogata Kōrin
Kundaikan Sōchōki, 46, 101
Kuo Hsi, 15; illustration of work of, 16
Kyoto monasteries: Daitoku-ji, 31, 89–90; Shōkoku-ji, 31; *see also* Bunsei; Josetsu; the Oguri painters; Sesshū; Shūbun; Soga, the

Liang K'ai, 17, 47; influence of, 50, 129; illustration of work of, 36
literati painting, 47, 133, 137

Ma Yüan, 17, 47, 67; illustration of work of, 20
Mi Fei, 15, 47, 103; illustration of work of, 14
Minchō, 44–45; Chinese influence on, 45; illustrations of work of, 43–45

Mokuan Reien, 43–44; illustration of work of, 58
Mu Ch'i, 35; illustration of work of, 32, 59; influence of, 46, 104, 132
Musō Soseki, 31, 87, 89

Nara Hōgen Kantei, 99; illustrations of work of, 100–01, 104
Ni Tsan, 17, 47
Nōami, 46, 69, 100, 101; illustrations of work of, 102–03, 106; *see also* Ami painters, the

Ogata Kōrin, 133; illustration of work of, 132
Oguri, the, 91, 93; *see also under individual artists*
Oguri Sōkei, 91; illustration of work of, 90
Oguri Sōritsu, 91; illustrations of work of, 93
Oguri Sōtan, 61, 65, 69, 91, 93; illustration of work of, 91

poetry and painting scrolls *(shigajiku),* 51, 53
Pu-tai, 21, 26, 123; depictions of, 25, 116, 122; *see also* ink-painting themes, Zen

Reisai, 117; illustrations of work of, 115–16
Ryōsen, 44; illustrations of work of, 41

Sekijō, *see* Soga Jasoku
Sekkyakushi, 117; illustration of work of, 115
Senka, 119
Sesshū, 69; background of, 70–71; compared with Shūbun, 76–77; disciples of, 82, 87–88; illustrations of work of, 63, 71–77, 80–81, 82–84; imitation of Chinese models, 75; as innovator, 76–77; landscape paintings of, 76–77, 82; later life of, 77, 82; and problems in attribution, 71–72; Shōkoku-ji career of, 71–72, 74; and visit to China, 72, 74–75
Sessō Tōyō, *see* Sesshū
Sesson, 87–88, 120; illustration of work of, 88
Shikibu Terutada, 119
Shitan, 35; illustration of work of, 40
Shōichi Kokushi, 31, 45; depiction of, 43
Shōkei, *see* Kei Shoki
Shōkoku-ji, *see* Kyoto monasteries
Shūbun: Chinese influences on, 67; disciples of, 69; documentary evidence on, 61, 64; illustrations of work of, 61, 64–65; influence of, 67, 69; as painter, 66–67, 69; and problems in attribution, 65–67; and visit to Korea, 61, 64–65
Shūgetsu, 82, 87; illustration of work of, 84
Shūkō, 87; illustrations of work of, 87
signatures and seals, *see under individual artists*
Sōami, 46, 100, 101; illustrations of work of, 99, 107; *see also* Ami painters, the
Sōen, 87, 120; illustrations of work of, 85, 86, 120
Soga, the, 91, 100; and Yi Su-mun, 64; *see also under individual artists*
Soga Jasoku, 69, 94–95, 98–99; disciples of, 99; illustrations of work of, 94–95, 96, 97; and problems in attribution, 95, 98, 99

Soga Shōsen, 99; illustration of work of, 98
Sōtatsu, *see* Tawaraya Sōtatsu
Sōyo, 99; illustration of work of, 98
Sugawara Michizane, 55–56; depiction of, 56; *see also* ink-painting themes, Taoist and Confucian

Taigaku Shūsū, 49, 50
Tan'an Chiden, 107
Tawaraya Sōtatsu, 133; illustrations of work of, 129, 135
Ten'yū Shōkei, 69
Tesshū Tokusai, 38, 44; illustration of work of, 30
Tōetsu, 82
Tōhon, 82
Tōshun, 87; illustration of work of, 87
Tung Yüan, 15, 47

Unkoku Tōgan, 132; illustrations of work of, 128, 134
Uragami Gyokudō, 137; illustration of work of, 136

Wang Meng, 17, 47; illustration of work of, 20

Wang Mo, 15
Wang Wei, 13, 15, 47, 103
wen-jen, see literati painting
Wu Chen, 17, 47
Wu Tao-tzu, 13

Yen T'zu-ping, 17; illustration of work of, 33
Yen Wen-kuei, 15; illustration of work of, 22
Yi Su-mun, 64–65; illustrations of work of, 60; *see also* Korea, influence of
Yosa Buson, 137; illustration of work of, 137
Yü Chien, 104, 129, 133; illustration of work of, 34–35

Zekkai Chūshin, 48, 55
Zen: influence of, on ink painting, 17, 21, 26–27, 29, 31, 38; introduction into Japan, 20–21; origins of, 17, 20; sects of, 20–21, 31, 89; *see also gozan;* Kamakura monasteries; Kyoto monasteries

The Arts of Japan Series

These books, which are a selection from the series on the arts of Japan published in Japanese by the Shibundō Publishing Company of Tokyo, will in future volumes deal with such topics as haniwa, ink painting, architecture, furniture, lacquer, ceramics, textiles, masks, Buddhist painting, portrait painting and sculpture, and early Western-style prints.

Published:

1 Design Motifs
2 Kyoto Ceramics
3 Tea Ceremony Utensils
4 The Arts of Shinto
5 Narrative Picture Scrolls
6 Meiji Western Painting
7 Ink Painting

In preparation:

Haniwa
Jodo Buddhist Painting
Furnishings

The "weathermark" identifies this English-language edition as having been planned, designed, and produced at the Tokyo offices of John Weatherhill, Inc., in collaboration with Shibundō Publishing Company. Book design and typography by Dana Levy. Text composed by Kenkyūsha. Engraving by Hanshichi. Printing by Nissha and Hanshichi. Bound at Oguchi Binderies. The type of the main text is set in 11-pt. Bembo with hand-set Goudy Bold for display.